# ST ANDREWS
# AT WORK

GREGOR STEWART

AMBERLEY

First published 2017

Amberley Publishing
The Hill, Stroud
Gloucestershire, GL5 4EP

www.amberley-books.com

Copyright © Gregor Stewart, 2017

The right of Gregor Stewart to be identified as the
Author of this work has been asserted in accordance
with the Copyrights, Designs and Patents Act 1988.

ISBN 978 1 4456 7088 1 (print)
ISBN 978 1 4456 7089 8 (ebook)

British Library Cataloguing in Publication Data.
A catalogue record for this book is available
from the British Library.

Origination by Amberley Publishing.
Printed in the UK.

# CONTENTS

Introduction                                                    4

The Middle Ages                                                 5

The Sixteenth, Seventeenth and Eighteenth Centuries            22

The Nineteenth and Early Twentieth Centuries                   37

Modern St Andrews                                              62

About the Author                                               96

# INTRODUCTION

St Andrews is known worldwide both as the home of golf and where William met Kate. This small, historic town on the east coast of Scotland does, however, have a long history, which has helped influence not just how the town has developed but also helped shape the country.

With the ancient ruins of a once all-powerful Catholic church, the oldest university in Scotland and thirteen golf courses (including the world-famous Old Course), St Andrews plays host to hundreds of thousands of visitors a year, many of whom return on a regular basis. In this book the author explores how St Andrews originated and grew through the hard-working people of the town, and how its industries have changed and adapted through time.

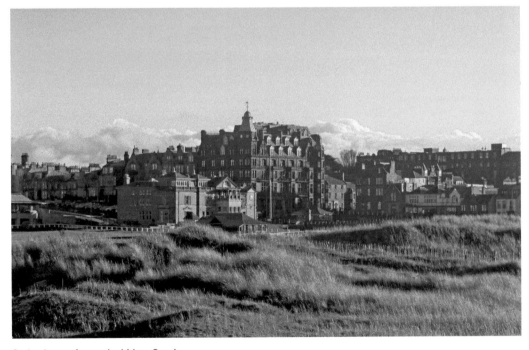

St Andrews from the West Sands.

# THE MIDDLE AGES

It was not until around the twelfth century that the St Andrews we know today really began to grow, although there was likely a small settlement of fishermen and hunters living in the area for centuries before. The founding of religious establishments would bring work to the area through the church, which placed ever-increasing demands on the locals to cater for the growing and developing town. With the approval of both the Crown and the pope, St Andrews would grow into a religious powerhouse, allowing the bishops and later archbishops to yield considerable power. Many people seeking a livelihood were attracted to the prosperous area, and with the church rulers always looking at ways to further improve the importance of the town, there were many opportunities for those willing to take them.

The following sections explore the way that St Andrews grew from its humble start to one of the most powerful places in Scotland.

## RELIGION

Religion may not be something that most people think of when they are asked to name a major employer, however, in St Andrews it was what provided many of the townspeople with a livelihood.

There are conflicting tales about how and when religion arrived here. The most commonly told is that some of the remains of St Andrew, a humble Greek fisherman who became the first Apostle of Christ, were brought to Scotland by a monk named Regulus during the fourth century when he was shipwrecked in what is now named St Andrews Bay. At that time the land was predominantly forest known as Muckross, meaning 'boars peninsula', as it was overrun with wild boars. Here, having been gifted the land by the Pictish King Hergust, the young monk established a religious settlement and a shrine to contain the bones of St Andrew was built. The more likely version of events is that the relics of St Andrew were brought to the small town that had started to establish itself here by Bishop Acca of Hexham during the eighth century. Whichever version is correct, the town became known as Kilrymont, meaning 'church on the royal mount', began to grow as a religious centre. In the year 906 it became the seat of the Bishop of Alba (Scotland), by which time people had begun to move to the town, forming small groups of clergy and living a communal life devoted to worship. In 1123, Robert, the Prior of Perth, was appointed as Bishop of St Andrews and he sought to establish a community of Augustinian Canons. The already established Celtic monks known as the Culdees did not

fit into the plans, as, although Christian, marriage was permitted for the priests and monks. The Culdees were offered the opportunity to become Augustian Canons; however this would mean changing their ways and so they declined. It was at this time that St Andrews was to start to grow as a religious powerhouse, bringing growth and prosperity to the town.

In 1140, King David I granted permission for a new religious burgh to be established at St Andrews. The Culdees had completed the construction of a new church around 1123, and in 1144 it was chosen as the base for the new religious centre, with the Culdee monks being forced to construct a new church for themselves. The church was renamed 'St Rules' and extended to provide additional accommodation, yet it was soon apparent that it was not large enough for the rapidly growing community and, in 1160, plans for a new, much larger church commenced. Work started in 1163, with the end result being St Andrews Cathedral, a building so vast that it was the largest in Scotland for around eight centuries, and included a priory and dormitories for all those who sought to join the religious order.

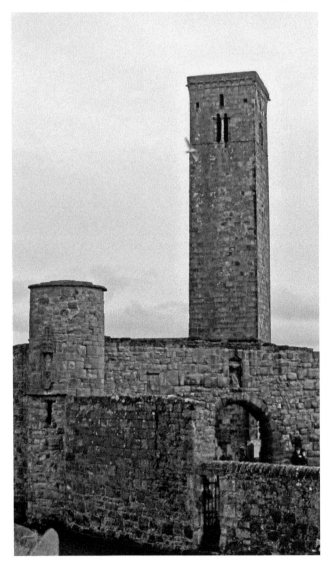

St Rules Tower can be seen well above the cathedral wall.

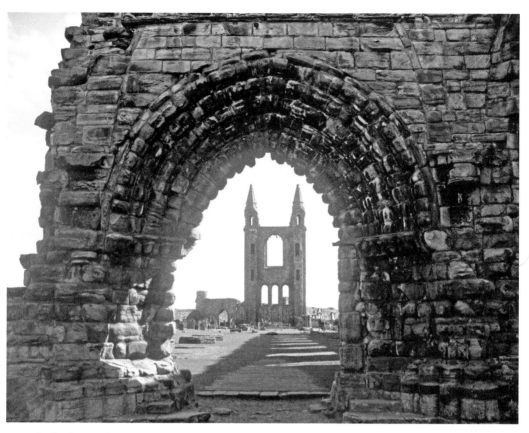

St Andrews Cathedral, looking through the main doorway. The section of building in the background is the rear of the cathedral, giving an idea of the size.

# STONEMASONRY

The establishment of a religious centre in St Andrews not only brought a livelihood to those directly involved, as people travelled to the area seeking work; it established a community around the cathedral walls. One of the most vital roles was that of the stonemasons. With the vast cathedral, associated buildings and wall being constructed, it is highly likely there would have been hundreds of masons working on the site. Although exact numbers are not known, it is estimated that it took around 400 stonemasons as well as their apprentices and labourers to construct a cathedral. The onus was on the Church to provide accommodation for the stonemasons while working on a religious establishment, and the community and the cathedral expanded to house the growing workforce.

Shortly after work began on the cathedral, it was decided that a suitably grand residence to match it should be built for the bishop – St Andrews Castle. When construction began on it, further employment was brought to the area. The importance of the stonemasons should not be underestimated; at the time these buildings were being built there were no architectural drawings to work from, and it fell upon the expert masons to not only carve the most ornate details to embellish the buildings, but also to prepare plans for the construction. A rare example of a mason's sketch, which was found on the underside of one of the fragments from one of the pillar, can be found in the cathedral museum.

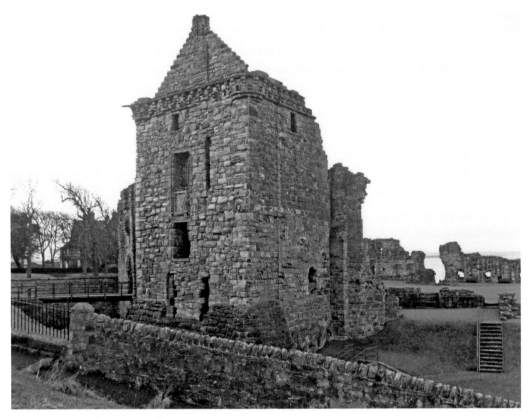

The remains of St Andrews Castle.

With stonemasons being known as 'journeymen' – they would travel to where the work was – there would have been a degree of determination to keep the masons working in St Andrews. One benefit of the town being declared a burgh was that any adult male who resided there for more than a year and a day was allowed to become a burgess. This meant that they were considered a citizen of the burgh and were entitled to the benefits this brought, such as being allowed to take part in the political life of the town and to have a say in what was happening. That said, with the cathedral taking almost 150 years to complete, the town had little to fear as there was enough work to keep the masons in work for generations – it would not be unusual to find fathers and sons working together, possibly even three generations working at the same time. It is believed that the stone to build most of the early buildings in St Andrews was quarried close to nearby Strathkinness, while in 1435 stone was brought from a quarry at Kinkell (an area to the north of the town) to construct the priory.

While the construction of the cathedral brought employment for many people, it was not without its risks and tragedies. The western gable was blown down during a storm in 1270 while work was still ongoing. It is not documented whether any masons lost their life as a result, but when that section was rebuilt, it was done so in a slightly different position to reduce the risk of further collapses. The masons also worked through the first War of Independence with England, during which, in 1304, Edward I took up temporary residence in St Andrews Castle and held parliament in the cathedral priory. The castle was badly damaged during this time and, before leaving to attack Stirling, the king had the lead from the roof of the cathedral stripped to make artillery for his forces. It is difficult to imagine the thoughts going

through the masons minds, having witnessed the wilful destruction of work that both they and their forefathers had painstakingly completed. The repair work did, however, bring more employment and despite the cathedral having been officially consecrated in July 1318 (in the presence of Robert the Bruce), the priory buildings had not yet been completed.

Further incidents saw yet more destruction. The castle was once again taken by the English, during the Second War of Scottish Independence in the 1330s. The stonemasons were put to work by the English forces to strengthen the defences of the castle, but a siege in 1337 saw the Scottish forces once again taking control and then go on to destroy the castle further to ensure that the English could not use it again. In 1378, the cathedral suffered a great fire, causing extensive damage, and just a few years later, in 1385, Bishop Traill ordered the rebuilding of the castle, both of which brought further work for the stonemasons. In 1409 a storm caused the collapse of part of the cathedral. The masons were also required to help build the growing town around the cathedral, including the university buildings.

One of the main difficulties for stonemasons, especially when so many were working on one building, was to ensure they were paid for the work they did, which was often based on how many stones they cut and laid. To ensure that they were fairly paid and no one else could claim their work, each stonemason developed a unique mark, which they caved into each stone they worked on. Often relatively simplistic in design to ensure they did not use much time to add to a finished stone, each one had to be unique. Some of these mason marks are still visible around the town today.

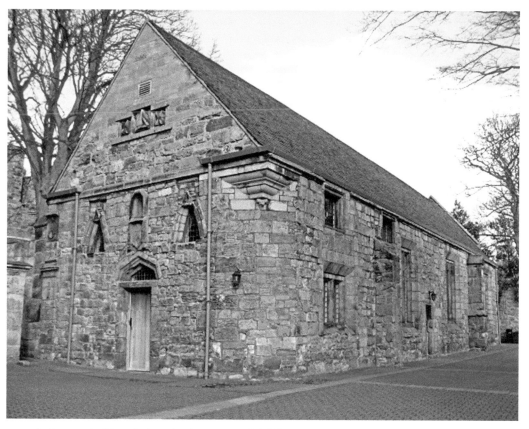

St Leonards Chapel dates back to around 1400.

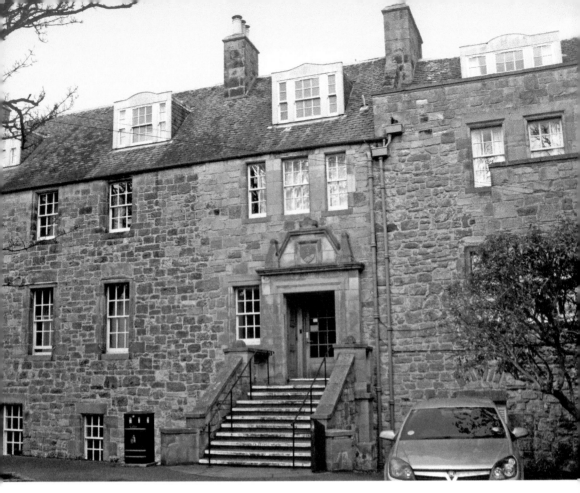

*Above*: Deans Court dates back to the fifteenth century and is a good example of the work of the early stonemasons.

*Left*: A mason mark at the Holy Trinity Church. (Kindly provided by Andrew Johnson)

Mason marks at the Holy
Trinity Church. (Kindly
provided by Andrew Johnson)

A mason mark at the Holy Trinity Church. (Kindly provided by Andrew Johnson)

A mason mark at St Salvator's Chapel. (Kindly provided by Andrew Johnson)

*Left:* A mason mark at St Salvator's Chapel. (Kindly provided by Andrew Johnson)

*Below:* A mason mark at South Court. (Kindly provided by Andrew Johnson)

# TRAVEL AND TOURISM

While most people would think of golf when asked about tourism in St Andrews, it is fair to say that the first 'tourists' were in fact the pilgrims, who travelled from all over the country and even from overseas to see the relics of St Andrew.

A Flemish town planner, known as Mainard, had been brought in to design the layout for the town with a focus on the cathedral, yet to still accommodate the travelling pilgrims. The result is much as we see today, with both North Street and South Street leading from the outer edges of the medieval town and heading to the cathedral in an almost arrow shape. This allowed the pilgrims to arrive via the gateway at the end of South Street (where the newer West Port now stands), then walk to the cathedral to worship and see the relics before being directed back along North Street to exit the town. Between these two streets sits Market Street, so named because this is precisely what it was: a marketplace. Here, both the townsfolk and pilgrims could buy supplies of food and drink, but there were also many souvenirs available for the pilgrims to buy as a memento from their visit. These included small bones and fragments of cloth, which the less than honest sellers would claim to have come from one of the saints, and also small badges. A few of these pilgrim badges remain in existence, dating back to the 1300s and depicting the effigy of St Andrew. The badges, made from tin and lead, had a hole at each corner allowing them to be sewn onto clothing; it was believed that by wearing the badge, the good luck and protection of the saint travelled with them.

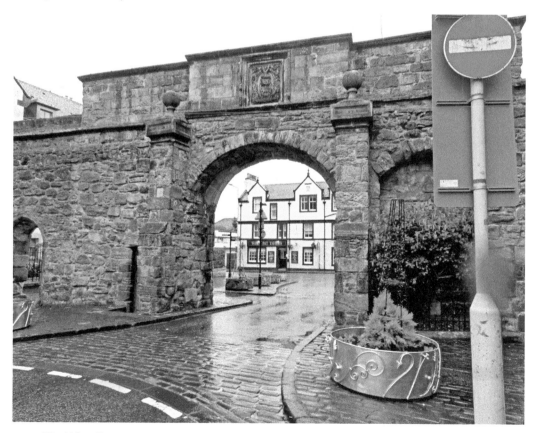

The West Port.

It is estimated that at the height of the popularity of pilgrimage to St Andrews, in excess of 10,000 pilgrims visited the town per year. That may not sound like many compared to today's visitor numbers, but it should be remembered that the journey the pilgrims had to take – often barefoot – was long and dangerous. With so many weary visitors arriving to the town, the need for food, drink and a place to rest grew. It became necessary to control the flow of people arriving at the cathedral, and so many were held outside the West Port and allowed entry in small groups. A place to provide the pilgrims with somewhere to rest was constructed, and bowls of a gruel-type food (and no doubt a cup of ale) were offered for sale while they waited, essentially creating what may have been the first pub in St Andrews. The Whey Pat Tavern stands in the area where this gruel house once was, and even takes its name from these times: 'whey' is the name given to the gruel, and 'pat' refers to the bowl in which it was served.

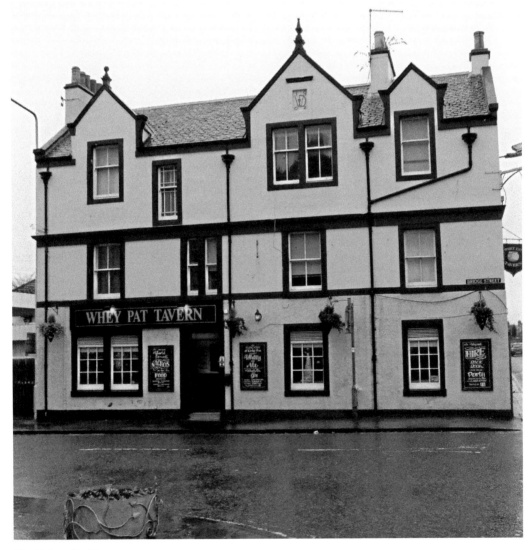

The Whey Pat Tavern.

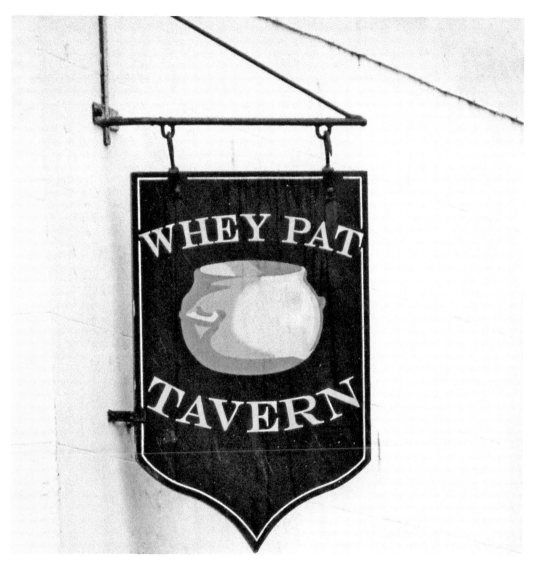

The pot of gruel on the sign of the Whey Pat Tavern.

# THE UNIVERSITY

St Andrews University is perhaps best known as where Prince William studied and met his wife, Kate Middleton. The university does, however, have a long history in the town. Having been founded in 1413, St Andrews is the oldest university in Scotland and the third oldest university in the English-speaking world.

The university origins can be traced back to the religious importance of St Andrews. Many canons were needed to both run and maintain the cathedral, yet most scholars had to travel to either England or Europe (mainly Paris) to gain the appropriate education to serve. This restricted those from poorer backgrounds from studying, and with what later became known as the Hundred Years' War between England and France starting in 1337, travel to both had become increasingly dangerous.

Already feeling the effects of these external influences with a reduction in numbers of people studying, Bishop Henry Wardlaw of St Andrews decided to take matters into his own hands and organised for a number of experienced clergymen from the cathedral to start teaching prospective students. This makeshift place of learning was a success and, with demand growing, Bishop Wardlaw issued the Charter of Incorporation and Privileges in 1412, making the fledgling university a formal corporate body to deliver studies in divine and human law, medicine and the liberal arts.

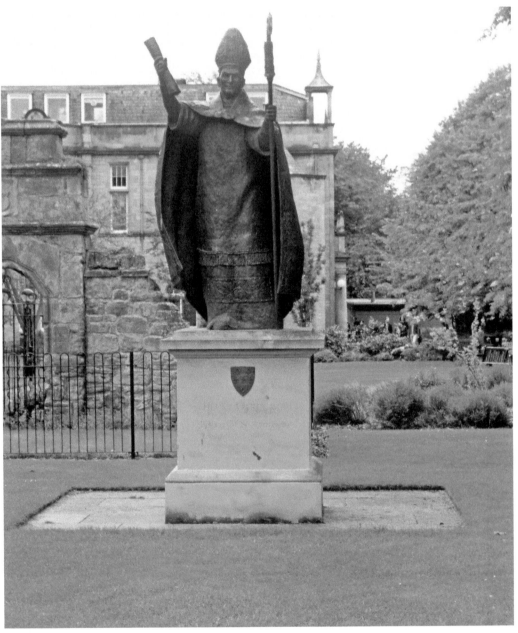

A statue of Bishop Wardlaw within the grounds of St Mary's College.

Needing more lecturers to deliver the teaching, anyone holding a permanent position within the Church was offered special leave to either teach or to carry out their own studies. Special privileges were also offered to those outside of the Church but who had involvement with the university, essentially the businesses in town that supplied them, such as stationers and parchment-makers. The privileges were extremely generous, including exclusion from being required to carry out guard duty at the castle along with exemption from paying income tax. This is a clear indication of how important the university was considered and how strong the desire of the bishop was to have people willing to work there. On 28 August 1413, Pope Benedict XIII issued a papal bull of foundation for a university of study for the faculties of theology, canon and civil law, arts, medicine and other lawful faculties, which finalised the establishment of the university.

The university not only brought work in the form of lecturers and support staff, the students required places to stay and for refreshments and a number of 'pubs with rooms' opened up around the town, bringing further employment. In total, six papal bulls were issued relating to the university. When the papal bulls arrived in St Andrews in 1414, they were welcomed with a ceremony involving over 400 clerics and a street party afterwards for the townsfolk, which gives further evidence of its significance.

Bishop Wardlaw took up the role of the chancellor to the university, and formal teaching commenced at the College of St John on South Street. Soon after, in 1450, the College of the Holy Saviour was founded by Bishop James Kennedy. This college not only provided the students with a place of learning, but also included accommodation providing them a place to stay and a church for daily prayers. A third college, named St Leonards College, was founded in 1512 and occupied the building that formerly provided care for the pilgrims, which is seen by many as a clear sign that the numbers of pilgrims visiting the town had diminished significantly by this time.

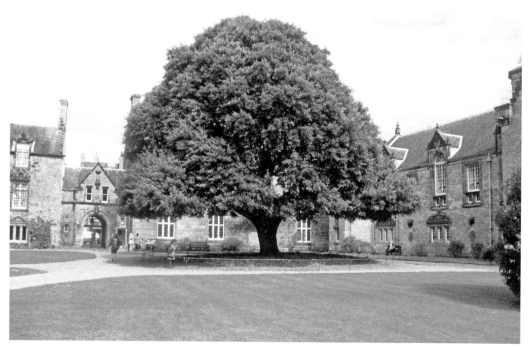

The sixteenth-century buildings of St Mary's College, dominated by a massive oak tree.

The King James Library, which joins St Mary's College.

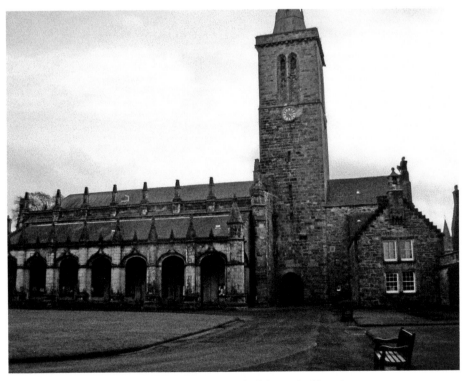

Part of the College of the Holy Saviour, now St Salvator's Chapel.

St Leonards College, now St Leonards boarding school.

# THE SIXTEENTH, SEVENTEENTH AND EIGHTEENTH CENTURIES

With the Protestant Reformation in full swing in Europe during the sixteenth century, it was only a matter of time until it arrived in St Andrews – home of the Scottish Catholic Church. Initial attempts to crush the Reformation by administering swift and brutal executions to anyone involved failed. Although there had been earlier persecution of reformers in the town, it was the burning of George Wishart outside the castle in 1546 that would be a pivotal point. Cardinal Beaton was Archbishop of St Andrews at the time and ordered the execution, yet he had underestimated the popularity of Wishart and how his supporters would react to his killing. Just a matter of weeks later a group of men sneaked into the castle, pretending to be workers, and assassinated Cardinal Beaton in his bedchamber.

They held the castle for around a year until French ships sailed into St Andrews Bay. The French were long-term allies of the Scots and, as a Catholic country, wanted to see Scotland remain Catholic. The castle was bombarded by cannons on the French ships as well as some that had been hoisted onto high vantage points on land. Knowing that the French forces were likely to be more lenient, the besieged men surrendered to them. Among those taken prisoner by the French was a preacher named John Knox. After serving for two years as a rower in French galley ships and spending some time in exile, John Knox returned to St Andrews and in 1559 delivered a sermon in the town's parish church. His preaching was so passionate that the townsfolk took the streets and attacked the town's Church-owned establishments, including the cathedral. Within a matter of weeks, all those connected to the Catholic Church were forced out of the town and the once grand buildings were ransacked. This was the beginning of the end of the control that the Catholic Church held over Scotland.

Mary Queen of Scots, having returned from France to Scotland, is believed to have visited St Andrews on three occasions between 1560 and 1565, staying at a property in South Street close to the cathedral. By 1561, however, the queen's advisors had begun to acknowledge the reformed Presbyterian Church, and, on their recommendations, she granted it some rights, yet stopped short of granting it the same full authority that the Catholic Church had enjoyed. Despite the visits from the queen, this was to be the start of a long period of decline for St Andrews.

## STONEMASONRY

Despite the levels of destruction, stonemasons remained a vital part of St Andrews. Archbishop John Hamilton, who succeeded Cardinal Beaton, tried to cling onto power in the face of the Reformation. The stonemasons were set to work carrying out repairs to St Andrews Castle,

which had suffered extensive damage at the hands of the French. Archbishop Hamilton was executed in 1571 for a crime he did not commit, yet further archbishops were appointed, although after the Reformation they chose to stay in private residences in the town rather than in the castle.

There would have been other work for the masons to carry out, restoring other damage the town had suffered during the Reformation; however, without the Church there was less work all round in the town, and people had less money to be able to pay for repairs. In 1606, Parliament ordered that the castle should be removed from the ownership of the Church and it was given to the Earl of Dunbar. In 1612 there appeared to be a glimmer of hope for the stonemasons still in the town: the castle being given back to Archbishop Gordon Gledstanes, whom immediately had essential repairs to the building fabric carried out. Around this time work started again on the university buildings, providing more work for the remaining stonemasons and attracting others to the town once more.

With talk of the cathedral's restoration lasting until 1634 (when Charles I ordered a feasibility report to be prepared), the stonemasons must have lived in hope of seeing work that would provide employment for generations once again, but that was not to be the case. When Charles I attempted to re-establish the estates of the bishop in 1635, it was not popular among the Scots, and in 1638 the Church of Scotland abolished the office of bishop. Charles II restored the position in 1661 but it was short-lived, and was finally abolished in 1689. Both the cathedral and castle quickly fell into a rapid state of decline, with the only

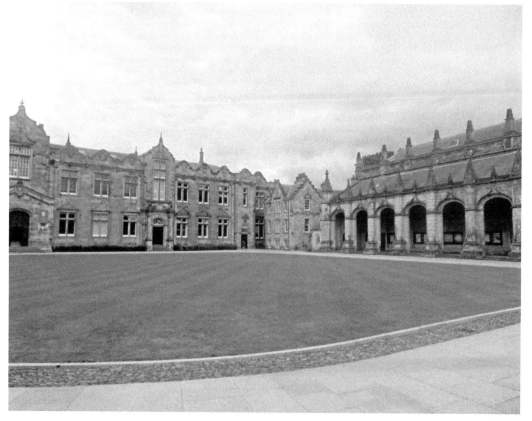

St Salvator's College was repaired after the Reformation.

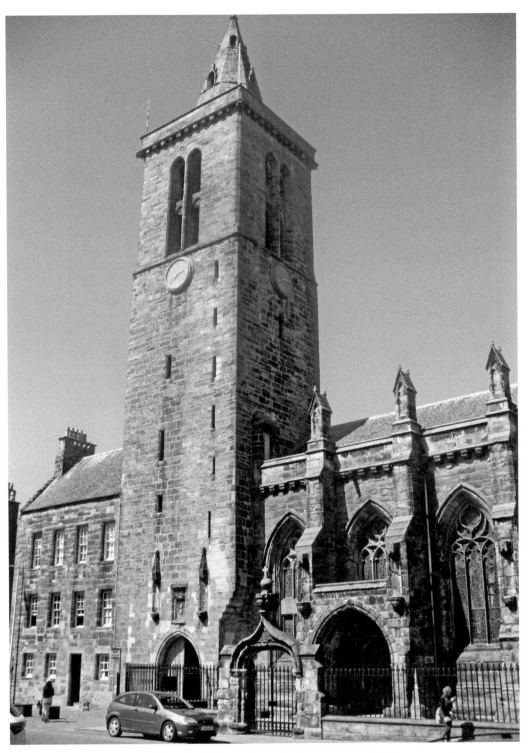

St Salvator's tower, restored after the Reformation after being extensively damaged when the French forces placed a cannon on the roof to attack the castle.

positive from it being the stonemasons now had a ready supply of stones. Sadly, with limited money in the town and no church to support local businesses, there was no work and the stonemasons of the town once again became journeymen.

# UNIVERSITY

In 1538, the fourth and final college under the control of the Church was created. Named the New College of the Assumption of the Blessed Virgin Mary, and founded by Archbishop James Beaton, the college aimed to preserve the teachings of the Roman Catholic Church – perhaps a sign that the early effects of the growing Reformation soon to sweep across Scotland were starting to be felt.

Despite the clear and strong ties between the university and the Catholic Church, the university thrived in the years after the Reformation. This is probably largely down to two contributing factors. The first being the reformer Patrick Hamilton, who had been a student at St Andrews University and had envisaged that St Mary's College (as the New College of the Assumption of the Blessed Virgin Mary is more commonly known) would play a vital part in the Reformation. Hamilton was burned at the stake for heresy outside the tower of St Salvators in 1528, yet remained a popular figure.

The second factor in the survival of the university was Principal John Douglas, who joined the reformers. Douglas realised that the immediate future of the university relied

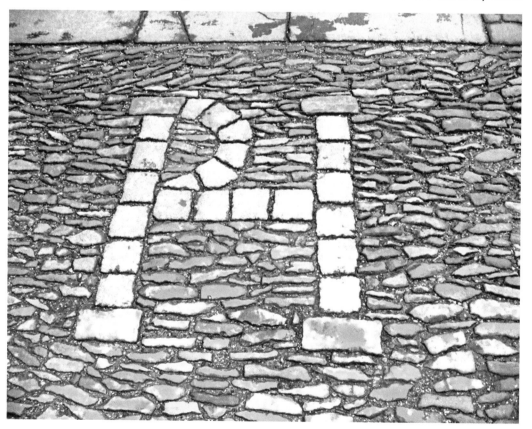

The letters 'PH' in the cobbles marks where Patrick Hamilton was burned at the stake.

on continuing the connection with the Church, so St Mary's College was re-established as the Faculty for Christian Studies, resulting in a relatively smooth transition. St Salvators was unfortunately not as lucky, with the ornate carvings depicting the saints and other biblical figures being destroyed, along with the stained-glass windows being damaged and an attempt to smash the tomb of Bishop Kennedy inside the building. Parliament Hall faced similar damage.

The university would also feel the financial impact of the Reformation. The privileges once granted to those associated with it by the Church were removed, and the funding that once came via the Church ceased. The staff would have no doubt felt the effects of this most, yet there was little alternative employment in the area. Meanwhile, the number of students attending the university remained high, maintaining the need for it to be adequately staffed. As a result of this all building work was stopped due to lack of funds. It was not until the start of the seventeenth century that the university would once again start both restoring and extending its buildings, partly thanks to the recognition given to the quality of the tuition provided bringing students from the Protestant parts of Europe.

The revival of the university, however, was shot-lived. As St Andrews fell into decline, so too did the university. In 1697, there was an attempt to have it closed and re-established in Perth. It was only thanks to delays caused by academic arguments about the suitability of Perth that saved the university, with the delays eventually causing the plans to be abandoned. In 1747, with a lack of students and a lack of funding, St Leonards College and St Salvator's College

Empty niches at St Salvator's Chapel.

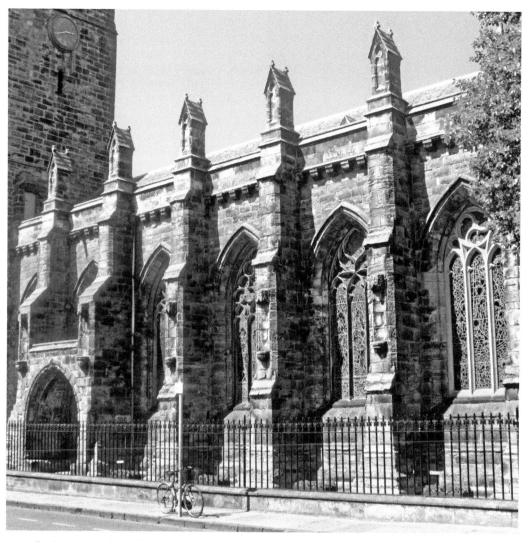

Parliament Hall on South Street with empty niches where statues once stood.

were merged to create the United College of St Salvator and St Leonard. By this time the university buildings were once again suffering from lack of maintenance and the lecturers were very poorly paid, with many only staying due to loyalty to both the university and the monarch. By the 1170s the university had only around 100 students, with most of the staff being forced to move on.

# FISHING

Fishing was a key part of St Andrews for many years, with early records indicating there may have been a small fishing community before the arrival of the relics of St Andrew. It was not until St Andrews began to suffer the economic effects of the Reformation, however, that the fishing industry would grow to become a significant employer in the town. Early records indicate that there were approximately seventy fishing boats in St Andrews Harbour in 1634,

which went out to sea on a regular basis and returned to the town laden with fish. At that time the harbour consisted of piers predominantly constructed with timber, and disaster struck in 1655 when a severe storm destroyed them. With fishing being the only viable local industry remaining, there was a degree of determination in rebuilding the harbour piers, and the castle and cathedral provided a supply of material to allow stronger stone ones to be built.

Fishing, however, was a tough and dangerous job. St Andrews Bay can experience extreme weather that can change rapidly. Rocky outcrops also extend from the land on either side of the harbour, and the water in the harbour itself is shallow. This resulted in boats having to wait in the dangerous bay until high tide before entering the harbour, by which time the rocky outcrops were concealed by the water, making it more difficult to navigate. Another problem was the location: with St Andrews Bay sitting between the Firth of Tay and the Firth of Forth, it was occasionally mistaken for one of the deeper, longer river mouths, with boats sailing in at high speed and being unable to turn when their mistake was realised. It is therefore not surprising to learn that many boats were sunk in the bay, with the wrecks causing further difficulties when approaching the harbour entrance. Once the boats reached the safety of the piers, they would be towed in on a long rope by the crew to their berth, where they could finally unload their catch.

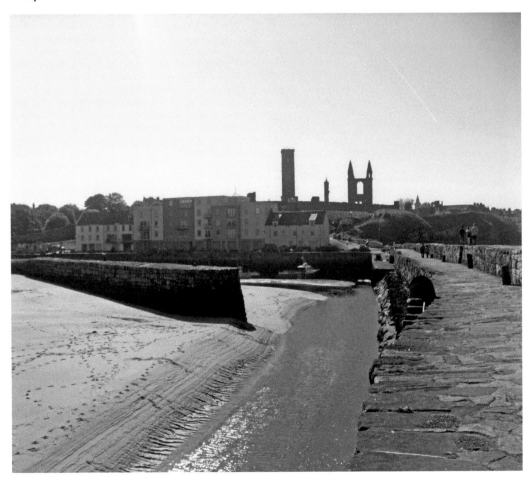

The entrance to St Andrews Harbour at low tide.

The rocky outcrops to the side of the harbour, clearly visible at low tide.

The rocky outcrops to the side of the harbour are mostly covered by the sea, making them a hazard.

The fishermen's working life was tough and home life was not much better. The homes the fishing families lived in were little more than slums, with overcrowding, poor sanitation and malnutrition being a real issue. The women would stay on shore repairing nets while the fishermen were out, and upon their return it would often fall to them to gut and prepare the fish. There is no doubt it was a difficult life, but their only option was to endure it.

As the town continued to decline, so too did the fishing industry. With fewer people in the town, demand for fish fell. The little money the fishing folk did make dwindled, making repairs impossible to carry out and more boats therefore becoming unseaworthy. Even the annual herring fishing season, which had supplied the fishermen with a mercifully plentiful catch for a time, was not to last. It is estimated that at the height of the season hundreds of buyers would arrive with horse-drawn carts to carry back their purchases, with some coming from as far away as Perth. Overfishing would see the stock dwindle, and the buyers went elsewhere. A knock-on effect of this was that the fishermen had to venture further out to sea; this yielded a larger catch but brought even more danger to the crew.

On 4 November 1765, the fishing community was to be dealt a blow that they would not recover from for some time. A small fleet of five boats left the harbour in the early morning, heading out to the favoured fishing spots. Shortly after the fishermen had cast their lines, a sudden storm approached, causing them to make the difficult decision of either risking their life or losing their catch and earnings. The storm was so severe that the decision was made for them, and they headed for the harbour as quickly as they could in treacherous conditions. When they reached the harbour mouth, the realisation swept across the crews that the tide was still out and there was insufficient water in the harbour for them to safely enter. With no choice but to wait, the boats sat in the bay, hoping that the turning tide would fill the harbour in front of them before the raging storm behind caught up with them. They could only wait

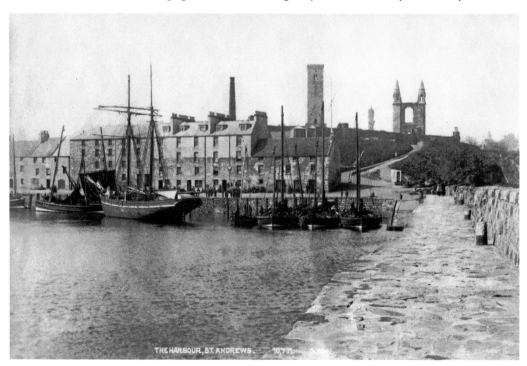

An old photograph showing the fishing fleet. (Supplied by St Andrews Preservation Trust)

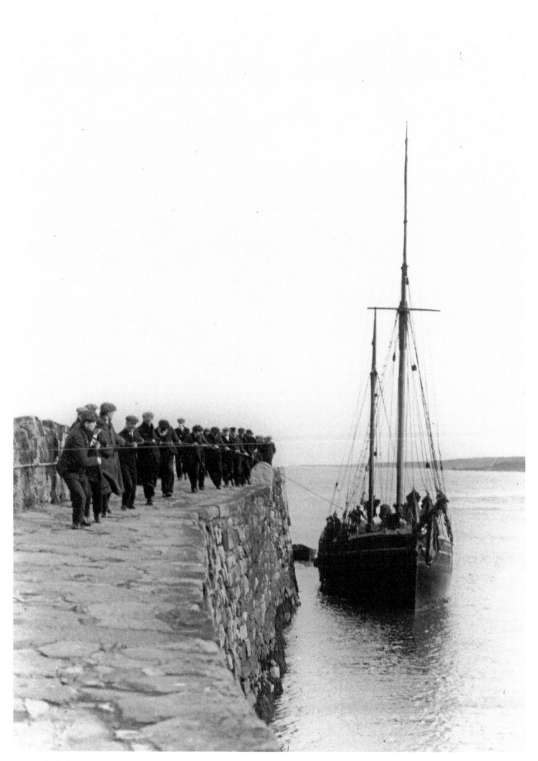

A fishing boat being pulled into dock. (Supplied by St Andrews Preservation Trust)

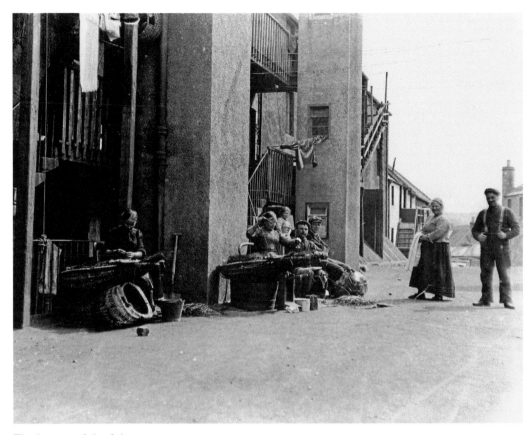

The homes of the fishing community.

a short while before necessity caused them try to enter the harbour. One by one the fishing boats sailed forwards in a line. One boat was struck by a massive wave, which lifted it up and dropped it on top of the boat in front. Witnesses describe one man being crushed by the falling boat, yet the rest of the crew escaped with their lives. Those on board the boat that was lifted by the wave were not so fortunate, and all perished. The other three boats were thrown against each other by the breaking waves, causing further destruction and loss of life. In total, three of the boats were totally destroyed, and two were so badly damaged they could not be used. Twelve fishermen lost their life, eleven of whom were married. To make matters worse, the approaching storm had alerted their wives, who had rushed out to try to help. Some waded into the shallow waters, throwing ropes and reaching out to the stricken vessels, but instead had to watch their husbands drown.

The tragedy would have deeper repercussions for the fishing industry than might be imagined. The five boats represented the entire fishing fleet in the town and without them the surviving fishermen could not return to the sea – not that many wanted to. Having witnessed friends, fathers and sons being taken by the waves, few had any desire to return to their old treacherous lives and instead sought employment on smaller coastal boats or as labourers onshore. Rather bizarrely, this disaster prompted the town authorities to take action, and in 1766, having raised around £2,700 (mainly through church donations), work started to extend the pier to create more protection. Sadly, with no boats nor men willing to take up the employment, this action was too late to save the fishing industry.

# GOLF

By the mid-eighteenth century St Andrews was a bleak place, filled with slum accommodation and grass growing along the streets. It was at this time that the fortunes of the town were about to turn. Golf had been played in the town since the fifteenth century as a pastime for the townsfolk. This, in turn, caused an issue for the monarchy as golf was replacing archery as a hobby, resulting in the armies not being able to recruit sufficient numbers of experienced archers. Three attempts were made by successive kings to ban the playing of golf, and every attempt failed. It was this transition from archery to golf that lead to the events that would save St Andrews.

The university had long held an annual archery competition known as the Silver Arrow, with the winner of the competition earning the right to attach a medal of their own design to the ceremonial silver arrow. In 1754, twenty-two noblemen and gentlemen got together and formed the Society of St Andrews Golfers and they all contributed to have a silver golf club cast to replace the silver arrow. With the new competition, in which it would be golf that was played, the winner would earn the right to have an engraved silver ball hung from the club. Rather than restrict the competition to the university students, it was open for golfers from across the country to enter. It was this decision that would reverse the decline of St Andrews.

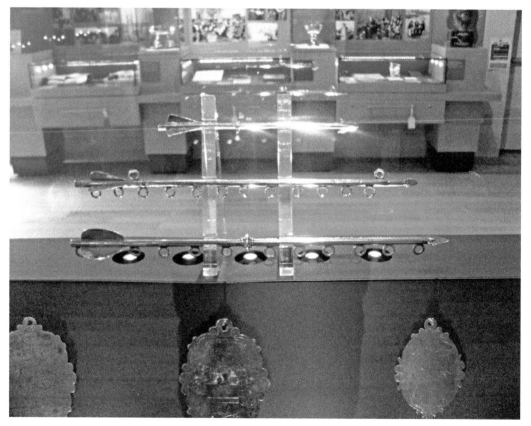

Three of the Silver Arrows with medals below. (Used with kind permission of the Museum of the University of St Andrews)

## James Boswell and Samuel Johnson

This is the site of Glass's Inn, 29 South St where Boswell and Dr Johnson had supper on 18th August 1773.

"We had a dreary drive, in a dusky night, to St Andrews where we arrived late. We found a good supper at Glass's Inn, and Dr Johnson revived agreeably... ...After supper, we made a procession to Saint Leonard's College, the landlord walking before us with a candle, and the waiter with the lantern."

(James Boswell, Journal of a Tour to the Hebrides with Samuel Johnson, 1785)

The Inn existed until at least 1830.

Erected by the St Andrews Preservation Trust Gordon Christie Bequest

A plaque marking the site of Baillie Glass's Inn on South Street where the Society of St Andrews Golfers met.

People travelled from all over to compete on the golf links that they had heard about. Upon arriving in the town, competitors required somewhere to stay and facilities to eat and drink, leading to the return of the 'pubs with rooms'. The growth was almost instant, with it being estimated that by 1760 St Andrews had around forty alehouses. The rapid increase in employment attracted people back to the town who all needed a place to live, with the increased money coming into the town leading to improved housing standards. It only took a few of the wealthy golfers to be able to look past the disarray and see the once grand stone houses that, with some investment, could be returned to their former glory, yet they were available to purchase for considerably less than equivalent properties in cities such as Edinburgh. Slowly but surely St Andrews started its journey back to prosperity. Each entrant in the Silver Club Competition was required to pay 5s, which brought funds into the Society of St Andrews Golfers. In 1766 it was decided that the members would play fortnightly, with them all retiring to Baillie Glass's Inn on South Street afterwards for a meal and drinks. Each member was required to pay 1s whether they attended or not, allowing the society to begin to build considerable funds.

The regular playing and competitions offered new opportunities, as those who knew the course best were hired as golf caddies. The knowledge of the caddies was in so much demand that in 1771 it was ruled that anyone found tipping the caddies more than 6d would be fined two bottles of claret in an attempt to prevent the wealthiest players from always securing the best caddies. In 1773, the competition was changed to be open to members of the St Andrews Society and the Leith Society only, a move that no doubt boosted both clubs membership and wealth.

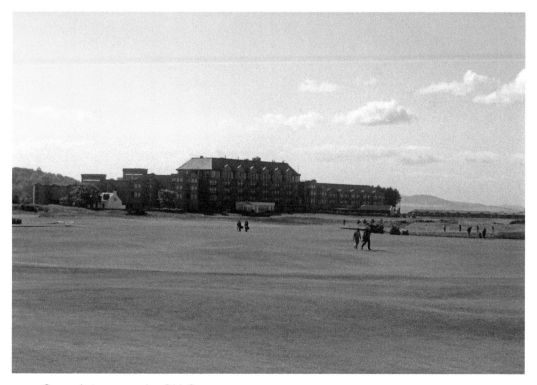

General view over the Old Course.

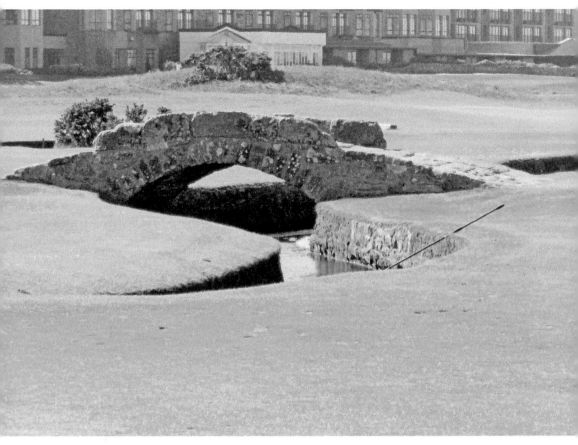

The Swilken on the 18th fairway of the Old Course, estimated to be at least 700 years old.

# THE NINETEENTH AND EARLY TWENTIETH CENTURIES

Having endured some of the hardest time imaginable, by the start of the nineteenth century St Andrews was well and truly on the road to recovery. The population had grown to over 4,000 people, a small figure compared to today's towns but in the nineteenth century that equated to a good sized town. With golf luring more and more people to visit, demand continued to grow for places to stay, eat and drink. The pubs with rooms were soon replaced by purpose-built hotels offering the highest levels of luxury at the time for the discerning golfer and his family – some even provided extravagances such as hot running water in every room! The Society of St Andrews Golfers became the now world-famous Royal and Ancient Golf Club.

As the popularity of the town grew as a holiday destination, all of the facilities to cater for the visitors had to be built and then adequately staffed. The town grew, with new streets being set and developments to the original historic town centre. The medieval streetscape was largely preserved thanks to Sir Hugh Lyon Playfair, who, having retired from the army, took up the role of Provost of St Andrews in 1842. He ordered the construction of new public buildings, including St Andrews Library, and had some of the streets widened to better accommodate the visitors arriving at the town, yet he was careful to maintain as much of the original character as he could. He was also an important supporter and promoter of a rail link to St Andrews, which finally came to the town in 1851.

While the university remained an important education establishment for the town, in 1833 Madras College was founded to provide schooling for local children. The school was founded thanks to a sizeable donation of £50,000 by Revd Dr Andrew Bell, a local man who had spent much time in Madras, India. While there he had developed a new teaching system that involved the senior pupils assisting teachers in the tuition of younger pupils. This was primarily brought about due to the lack of teachers, a problem St Andrews also faced at the time – when Madras College opened it only had nine teachers. Dr Bell was keen for the 'Madras System of Education' to be used in the UK, and at the time of his death around 10,000 schools had adopted his methods. In 1877, St Leonards School was founded, adding to the education establishments in the town.

A clear sign of the rapid revival of St Andrews was its population change, which by 1901 had grown to over 9,000.

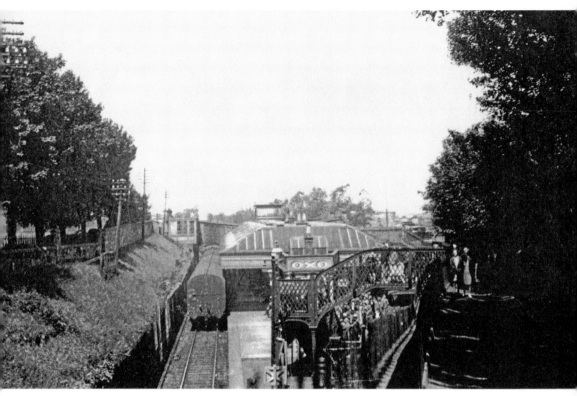

St Andrews railway station.

THE REVEREND DR ANDREW BELL, 1753-1832
FOUNDER OF MADRAS COLLEGE

AN EDUCATIONAL REFORMER AND PHILANTHROPIST, HE WAS
BORN IN ST ANDREWS. IT WAS WHILE SERVING IN MADRAS
IN INDIA THAT HE DEVELOPED A FORM OF SCHOOLING WHERE
THE OLDER PUPILS TAUGHT THE YOUNGER. WHEN HE RETURNED
HE INTRODUCED HIS "MADRAS" OR MONITORIAL SYSTEM AS AN
ECONOMICAL FORM OF MASS EDUCATION. THE IDEA SPREAD,
MADRAS SCHOOLS APPEARING IN CANADA AND AUSTRALIA.
AMONG HIS OTHER LOCAL BENEFACTIONS WAS THE BELL FUND
FOR THE BENEFIT OF ST ANDREWS. HE ENDED HIS CAREER AS
PREBENDARY OF WESTMINSTER ABBEY, WHERE HE IS BURIED.

Memorial plaque for Dr Bell outside Madras College.

# STONEMASONRY

With the growth of the town, old buildings had to be restored and new buildings had to be built, and as a result the journey men arrived back in St Andrews in large numbers. The slum buildings were cleared and demolished to make way for improved housing and businesses. Many of the buildings made during this time remain in use today, which shows the quality of the masons' work.

One such building is the prestigious Madras College, mentioned earlier. Constructed on South Street behind the remains of Blackfriars Chapel, the building has a fine ashlar finish – one that required the masons to work each stone into a square shape with flat faces. The internal quadrangle was constructed in the design of a round arched cloister. The inspiration for the cloisters perhaps came from Blackfriars Chapel, which must have been quite thought provoking for the masons working in the shadow of the chapel built by their predecessors.

Construction of the Royal and Ancient Clubhouse, which sits in a prime location overlooking the first tee of the Old Course, started on 13 July 1853. The event was marked with much celebration, with a procession leaving Madras College and making its way to the site of the clubhouse, complete with a band! The foundation stone was laid by Freemason John Whyte Melville, who reportedly called for 'the Great Architect of the Universe' to bring blessings

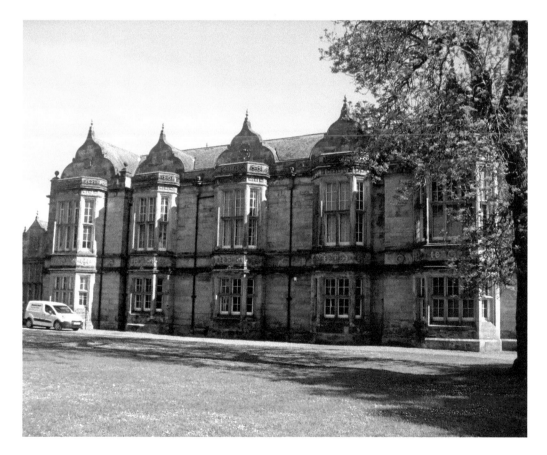

Madras College, South Street.

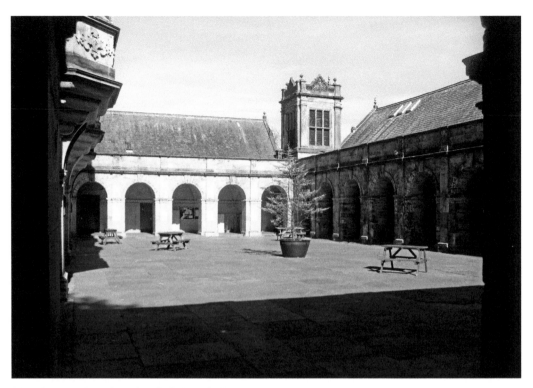

The cloistered quadrangle of Madras College.

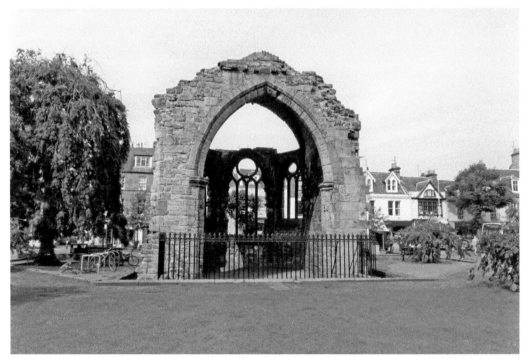

The remains of Blackfriars Chapel.

upon the work. The building we see today has had several additions over the years; however, the original was still completed to a very high standard and included stone fire places. Although the exact number of masons working on it is unknown, construction was completed in just eleven months, indicating that the clubhouse alone gave employment to a large workforce.

It was not just the construction work that provided plentiful employment for stonemasons. In the mid-nineteenth century there was a realisation that both the cathedral and the castle represented great monuments of both the town's and the country's history, so may be of interest to the tourists coming to the town. Unfortunately, after centuries of neglect and quarrying, the grounds of both buildings were nothing more than a rubbish dump, and so work was started to clear the debris. In doing so, between half a meter and a meter of stonework to all the buildings and walls, which had been covered by the collapsed rubble, were exposed and found to be in poor condition. Teams of stonemasons were drafted into the town under the supervision of the Woods and Forest Department to carry out repairs to the stonework and replace the damaged mortar. Grand buildings also continued to be built well into the twentieth century, ensuring demand for the work of the masons continued.

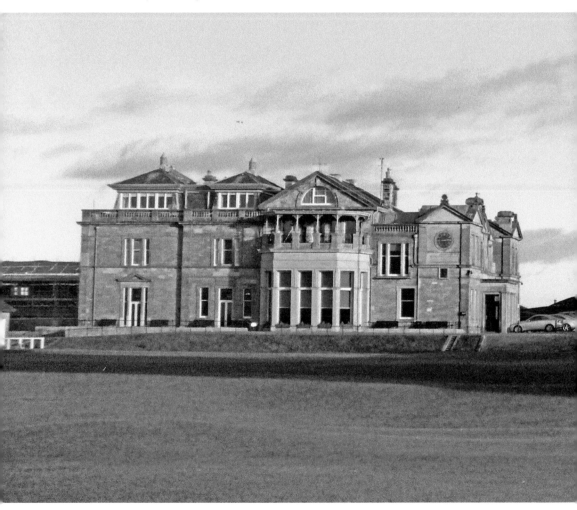

The Royal and Ancient Clubhouse.

A memorial to Sir Playfair outside the Royal and Ancient Clubhouse.

SIR HUGH LYON PLAYFAIR
PROVOST OF ST. ANDREWS
1842 – 1861
TO WHOM THE BURGH OF ST. ANDREWS
OWES ITS TRANSFORMATION FROM A
MEDIAEVAL BURGH INTO A MODERN TOWN

A memorial plaque to Sir Playfair at the top of Queens Gardens.

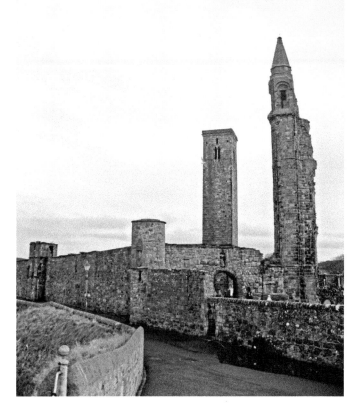

A section of the restored cathedral wall.

Mount Melville House, just outside St Andrews. A fine example of stonemasonry at the start of the twentieth century.

# UNIVERSITY

Despite the renewed fortunes of the town and growth in population, the university did not experience any immediate boost to student numbers. Despite additional courses being offered and a Professor of Chemistry being appointed in 1840, there were only around 150 students registered by the 1870s. However, Sir Playfair, in his role as provost, had secured a number of grants to improve the university buildings, allowing essential work to be carried out. In hindsight, that was very fortunate for the university, and by the end of the nineteenth century things had begun to change.

In 1876, in an attempt to boost numbers, the university elected to allow female students to study courses almost equivalent to those the males studied, and by 1896 a separate hall to accommodate the growing numbers of female students had to be constructed. In 1889, the university received a significant boost in its wealth in the form of what became known as the Berry Bequest. Alexander Berry studied at St Andrews and became a surgeon before moving

to Australia, where he obtained some land and established the first European settlement on the South Coast of New South Wales. He is thought to have become Australia's first millionaire and, upon his death, he left around 20 per cent of his fortune to the university. His brother David Berry also left around £100,000 to the university.

In 1897, St Andrews University founded the University College in Dundee as a centre of medical, legal and scientific excellence. The direct rail link made it easier for prospective students to travel to Dundee – St Andrews University was being talked about once again. The upper classes from around the country seemed to take some pride in sending their children to the oldest university in Scotland, and student numbers began to rise – as did the university's funds.

With such boosts to the finances of the university, more staff were recruited. Additional buildings were also required. One thing that is perhaps unique about St Andrews is that the university never relocated to a single site campus, instead it is dotted around the town in various buildings situated between businesses and homes.

The university centre for film studies located in an old house.

The University School of International Relations located in an old house.

# FISHING

An incident on 5 January 1800 would lead to the revival of the fishing industry in St Andrews. It was said to be a bitterly cold day, with driving sleet keeping the people of St Andrews indoors, when word broke that a small boat had run ashore in the bay. Many rushed to the rescue to see the boat, *Janet of MacDuff*, stuck on a sandbank with each wave causing more damage. The crew were clinging to it for dear life. With the weather conditions as they were no one seemed to know what to do, until a young student named John Honey broke through the crowd. With a rope around his waist – held by his fellow students – he rushed into the sea and, with a determined effort, managed to swim out to the boat. The rope now formed a lifeline that the crew could use to pull themselves to shore, but all were too weak from days at sea and the effects of the storm. Without a thought for his own safety, John Honey took one of the crew back to shore, before using the rope to guide himself back to the stricken vessel. He repeated this until all five crewmen had been saved. This miraculous rescue prompted funds to be raised for the town's first lifeboat, which arrived in 1801.

With the memory of the 1765 disaster dwindling, and the sense of some security thanks to the elongated pier and new lifeboat, thoughts returned to restoring the fishing fleet in St Andrews. A Mr Dempster made a proposal that he would bring two fishing boats from the Bressay Sound, off Sheltand, where he owned a small estate. The crews were to travel with the boats and would be paid 10s a week, plus a percentage of the sale of the fish the caught. It was also proposed that when the boats could not make it out to sea, the men would still

be paid their 10s. It was agreed that their catch would be put up for sale in St Andrews first, leading to the men becoming known as the town's fishers. The town council accepted the plan and, in 1803, the boats with six crew on each arrived in St Andrews.

It was a short-lived plan, with one of the boats returning to Shetland after just two months and taking two of the crew members of the remaining boat with it. The Shetlanders who remained were Andrew Manson, Lowrie Davidson, Lowrie Burns and Archie Lister; all four married local women in St Andrews. This signified the start of a new fishing community in St Andrews, with the boat from Shetland joining the three smaller vessels already in St Andrews Harbour.

Initially fishing only a short distance offshore, the boats each cast three lines per man with 250 hooks on each line. They were soon landing a plentiful supply of fish, which, true to their agreement, were put up for sale in Market Street. With the financial incentive of regular pay and a growing demand for fish, the fishing fleet gradually grew, with bigger and better boats. By the 1830s boats from St Andrews were sailing as far north as Wick, where there they fished for crabs. Mussel beds in the mouth of the River Eden provided a plentiful supply of free bait for the fishermen, which was gathered by their wives and helpers.

By 1882, the fishing fleet in St Andrews had grown to twenty-four large boats capable of deep sea fishing with nets, along with another twenty-four smaller boats that mainly fished with hand lines and for crabs. In total, the local fishing industry directly employed over 200 men, with many others employed in the support network of ship and gear repairs. The Eden mussels were also bringing in revenue, with an estimated £500 being collected by the town council every year, plus a further £200 from the shells. This may not sound a lot, but, for comparison, the Royal and Ancient were paying £5 annually for the rights to play golf on the Links.

While fishing had grown to be a sizeable enterprise in St Andrews, it remained a dangerous occupation and ships were still lost in and around St Andrews Bay. Despite this, in 1938 the decision was made to relocate the lifeboat from St Andrews to nearby Anstruther.

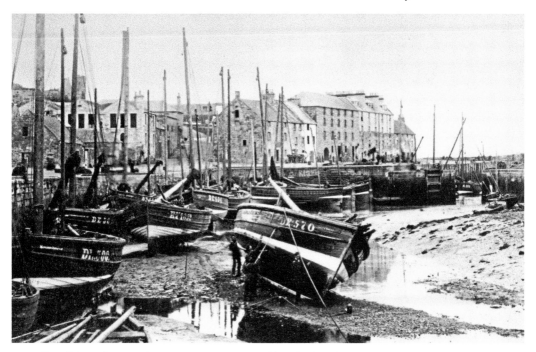

The fishing fleet in the harbour at low tide. (Supplied by St Andrews Preservation Trust)

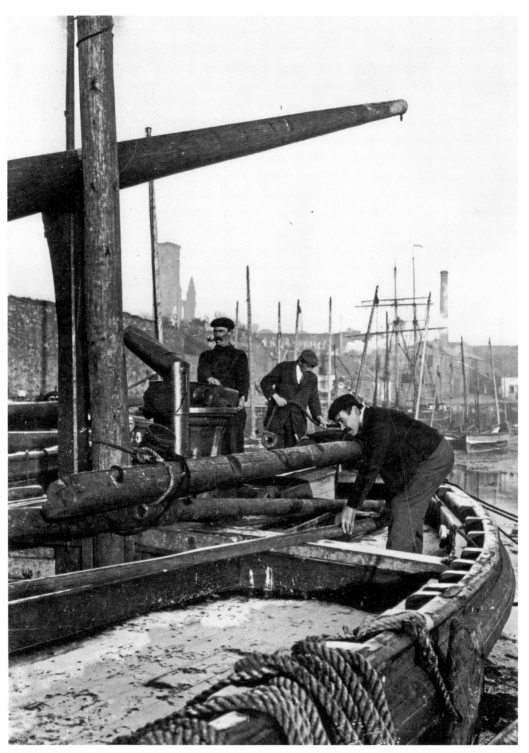

The first family to have a motor in their fishing boat, *c.* 1915. (Supplied by St Andrews Preservation Trust)

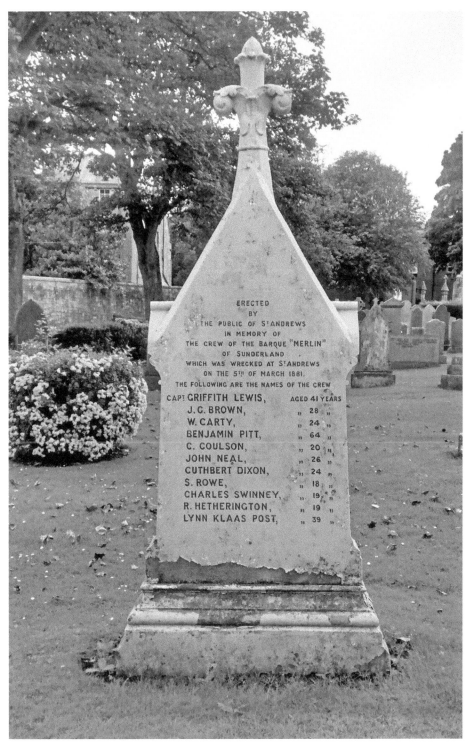

Memorial stone in the Eastern Cemetery to the lost crew of the *Merlin*, which was wrecked at St Andrews in 1881.

Memorial stone in the Eastern Cemetery to the lost crew of the French ship *Hoche*, lost off the coat of St Andrews in 1915.

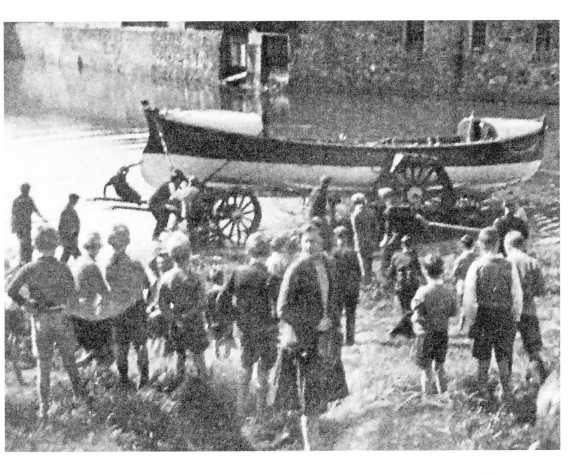

The St Andrews Lifeboat, named *John & Sarah Hatfield*, leaving on 10 September 1938.

# GOLF

While golf itself was giving many people employment in the design, maintenance and management of the courses, along with the ever-increasing number of caddies, the industry of the manufacture and production of golf equipment was growing beside it.

The first major manufacturer in St Andrews was R. Forgan & Son. Although founded in 1856, the company's involvement in manufacturing clubs can be traced back to 1819, when Hugh Phillip, a local carpenter, was appointed by the Society of St Andrews Golfers as their club manufacturer. By using different woods – such as pear or apple for the club heads and ash for the shafts – Phillip revolutionised the manufacture of golf clubs. It was his nephew Robert Forgan who bought the business in 1856 and would take the company on to become a major success.

Forgan's became the first golf club manufacturer to use hickory, which was imported and dried in large sheds that sat at the side of the seventeenth fairway of the Old Course. These sheds have been reproduced by the Old Course Hotel and remain an obstacle for golfers. The sheds could hold around 8,000 rods, which stayed there for twelve months before being rounded and used on clubs. The company was appointed as golf club makers

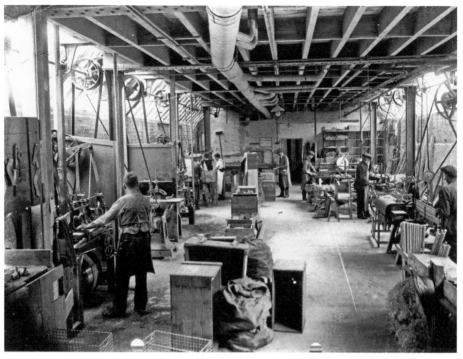

Workers inside Forgan's Golf Factory. (Supplied by St Andrews Preservation Trust)

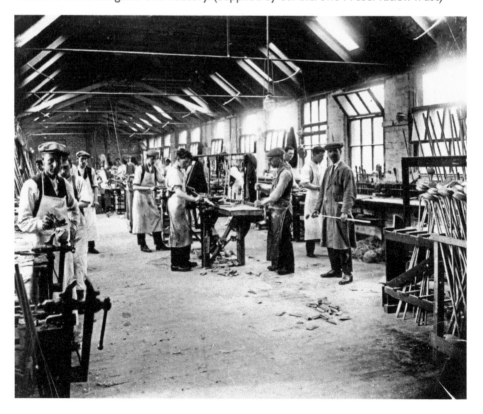

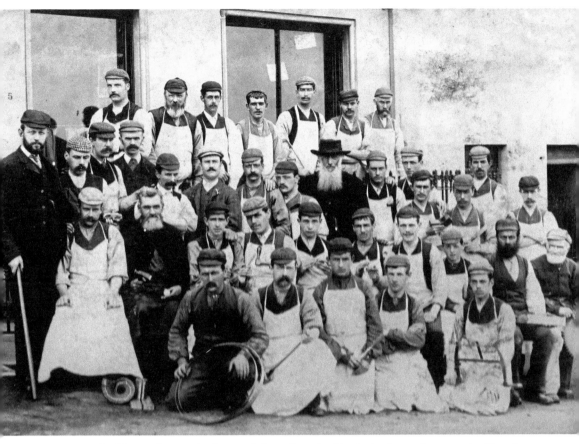

The staff of Forgan's outside the workshop. (Supplied by St Andrews Preservation Trust)

to Edward VII in 1902 following an earlier visit to the factory by the Prince of Wales, who they presented with a specially made set of clubs. By 1895, Forgan's was employing around forty people in the manufacture of golf clubs and by 1900 that figure had increased to fifty. The company also employed office staff and assistants and operated from a premises on Market Street and the Links.

While several other golf club manufacturers established themselves in St Andrews, probably the most notable rival to Forgan's was Tom Morris. Old Tom, as he is affectionately known, was a highly successful player, greenkeeper and course designer, and he was able to use these skills to perfect the design of clubs. Although only employing three people from his workshop on the Links, his clubs were in high demand, and in 1864 after a time away from the town the business took off. Old Tom stayed active in the world of golf until his death in 1908.

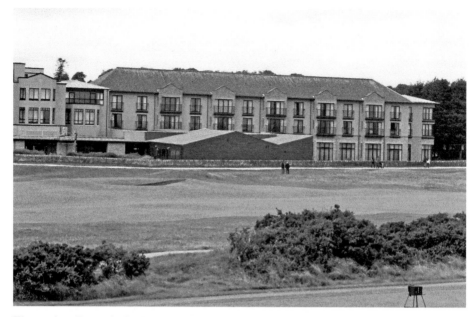

The replica Forgan's sheds at the Old Course Hotel.

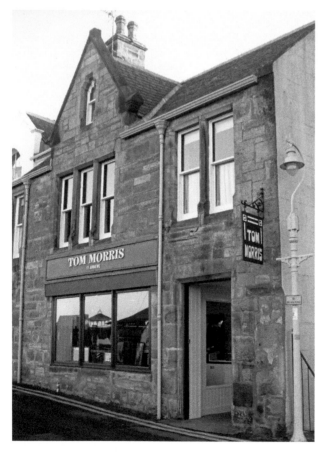

The Tom Morris shop
still operates from his old
workshop.

The former Forgan's workshop, now operated by the Royal and Ancient. This building is believed to be the oldest surviving golf club factory in the world.

# TRAVEL AND TOURISM

St Andrews grew steadily as a tourist destination in the early part of the nineteenth century, but it was the introduction of the railway line that really saw the town grow as a holiday resort. The opening of the Tay Rail Bridge in 1878 provided direct links from the north of the country as well, although it was initially short-lived – the Tay Bridge Disaster occurred just a year later – the new rail bridge was opened in 1887, reintroducing the direct link.

The demand the visitors brought to the town were considerable and varied, with hotels of all sizes being constructed to cater for varying clientele. Visitors ranged from ordinary working people from the cities seeking some fresh sea air to celebrities and even royalty, all seeking the best that St Andrews could offer.

Sea defences were put up to protect key sites, including the Links and the castle, to safeguard them for the future, and purpose-built bathing ponds were added at two of the beaches. In 1867, the St Andrews Ladies Putting Club was established to offer the ladies a gentler version of golf. A rough patch of ground was purchased, and the course was laid out by Old Tom Morris to create a miniature version of the Links. A milder version of the Silver Club Competition was also created, with a gold locket being presented to the winner. The club's putting green was open to club members only until 1920, when, to boost funds, members of the public were allowed to play a round for a small fee. Tearooms also became a frequent sight in St Andrews – probably initially established to cater for the women while the men were golfing.

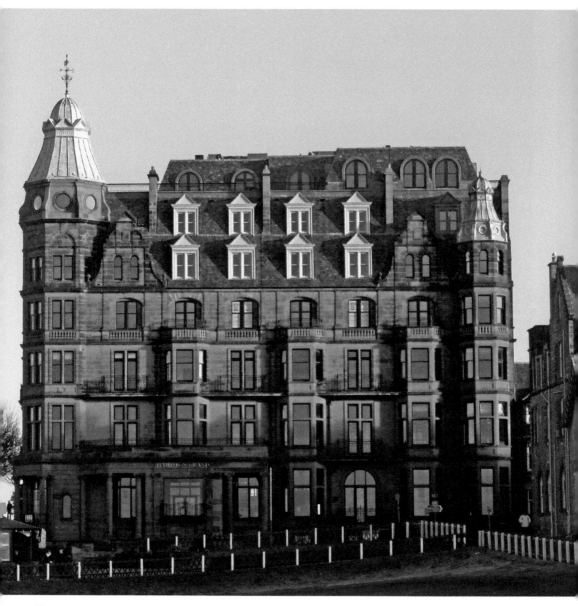

The Hamilton Grand. Originally opened as the Grand Hotel in 1895, this hotel offered the highest standards and attracted royalty. It later became student residences before being returned to luxury accommodation.

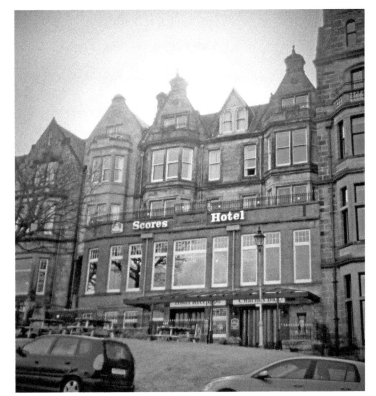

*Right:* The three-star Scored Hotel sits beside the Hamilton Grand offering quality accommodation.

*Below:* The Tudor Café.

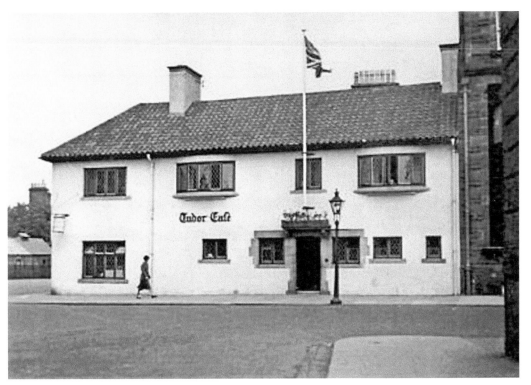

The Victoria Tearoom, now a pub.

In 1873, the golf Open Championship was played for the first time in St Andrews. With both Old Tom Morris and his son Tommy dominating earlier championships, there was quite an excitement about the competition coming to their town, bringing a large boost to the tourism. At the end of the First World War, American players began to reach the top of the leader board in the Open Championships, placing locations like St Andrews on the map as an international tourist destination.

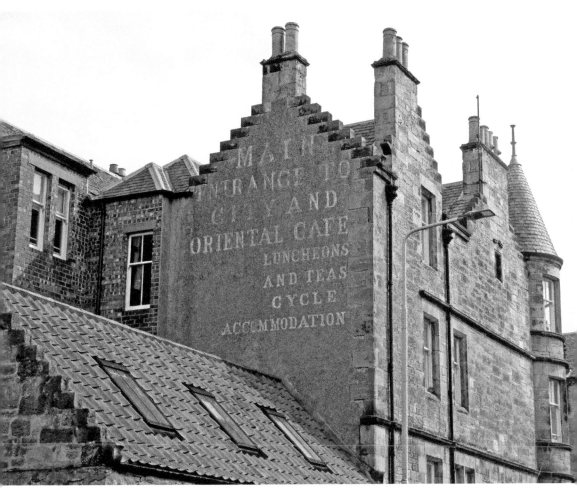

Old sign writing that remains for the Oriental Café.

# BREWERIES

St Andrews has a long history with brewing that stretches back to the early days of the religious communities. According to *The Penny Cyclopaedia of the Society for Useful Knowledge* (published in 1834), St Andrews had between sixty and seventy breweries at the end of the sixteenth century. With so many, it is easy to tell that they were all very small and produced a very limited about of beer.

It was in the nineteenth century that larger brewers moved into the town, creating industrial-sized breweries and providing considerable employment within the town. The West Port Brewers operated from a premises at the end of South Street. In 1864, this was purchased by William Haig (best known as a producer of whisky), who operated successfully for a number of years.

The malt barns for the West Port Brewery.

Haigs also operated another brewery in the village of Guardbridge, just a few miles outside St Andrews. Situated at the head of the Eden Estuary, this building started life as a whisky distillery in 1810 before being closed in 1860. At that point most of the building was redeveloped into a paper mill, although part of the building remained a brewery trading as Haig, Sons & Laing. In the 1890s, the brewery was closed and the building was incorporated into the paper mill.

The Argyle Brewery on Argyle Street was established around 1825. Originally operated as a partnership between two local brewers, Mr Ireland and Mr Halkett, by 1827 it was under the sole ownership of Mr Ireland. The brewery is described as having consisted of a group of two- and three-storey rough stone buildings around a central courtyard. A three-storey brewhouse was topped with a tall red and white brick chimney, and a bore hole that was in excess of 200 feet deep provided the water supply.

In 1860, the company was taken over by Mr Ireland's son, David Stevenson Ireland, until his death in 1890, after which the company was operated as a limited company known as D. S. Ireland Ltd. At the height of the company's success it was employing over forty people; however, in 1902, it ceased to trade and in 1906 the buildings were bought by Wilson and Co., a local aerated water manufacturer and bottler.

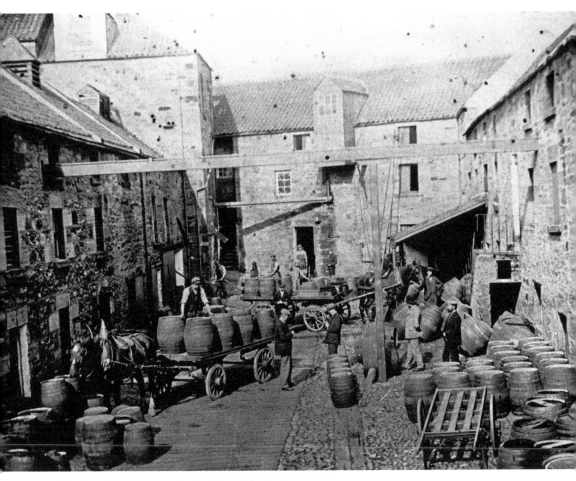

The Argyll Brewery at the height of the business.

# MODERN ST ANDREWS

Throughout the two world wars of the twentieth century, St Andrews played its part in aiding the war efforts. Hotels were turned over to the armed forces, and many Polish soldiers came to the town after the invasions of their home country. Businesses tried to continue to operate, but with so many of the men away at war there was a shortage of labour. On 6 August 1942, St Andrews would feel the full effect of the war, when high-explosive bombs were dropped above the town by a German warplane. One made a direct hit with a house on the corner of Nelson Street, completely destroying the property and the neighbouring house. It is thought St Andrews had not actually been the target and that the plane was trying to dump its heavy cargo into the sea as it flew home, but that was little consequence for those effected. In total twelve people were killed, and a number of others injured in the bombing.

My grandfather, William Stewart, was caught up in the attack. He was a fireman in the town at the time. The fire engine was stored near the harbour and the fire station was situated on Bridge Street, close to the entrance to Nelson Street. When the air-raid warning sirens sounded, he rushed to get the fire engine and took it to the fire station, a route that would take him perilously close to the bombsite. The bombs landed just as he was entering the fire station, and a large piece of shrapnel hit the fire station gates, missing him by inches. Despite this near miss, he and the fire crew were quickly on site extinguishing the flames.

After the Second World War, St Andrews quickly began to recover and, as with most towns and cities, considerable housebuilding took place. The growth of the town provided mainly social housing for those moving to the area to take up employment. In 1969, the railway line to St Andrews closed due to losses being made on the goods transportation side, with much improved road links bringing competition to the railways. This did not significantly affect the tourist numbers visiting the town as by then many people owned cars and could still visit. By the 1970s, national housebuilders had come to St Andrews, constructing large estates of private housing that further extended the town. The medieval centre remained substantially unaltered, with the exception of modern shopfronts being added to many of the buildings. The changing demands and expectations of the visitors along with rapidly growing student numbers saw businesses and facilities having to adapt to survive. Today, St Andrews remains an incredibly popular destination for tourists and students, as well as a highly desirable place to live.

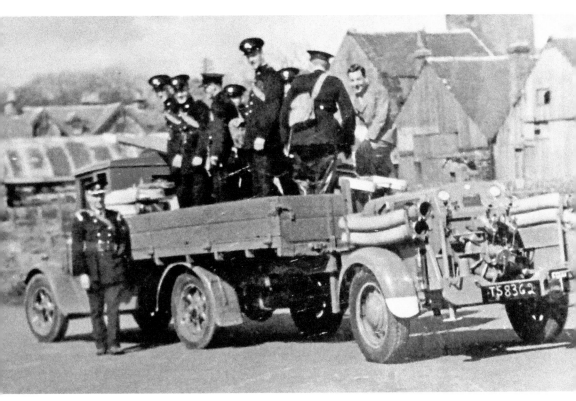

The St Andrews Fire Crew, including my grandfather.

# STONEMASONS

Immediately after the wars, stonemasons were in demand carrying out essential repairs and maintenance to many buildings in old St Andrews; however, with changing building techniques demand soon started to dwindle – not just in the town, but across the country. Old methods quickly began to be forgotten in favour for building with brick, and later timber. New university buildings were being constructed; however, the stonemasons were making way for the steel workers.

The listing of buildings with a local, regional or national importance began in Scotland in 1945. By around 1970, many of the buildings in St Andrews town centre had been listed by Historic Environment Scotland and a conservation area was established. As a result, many alterations and repairs needed to be carried out by traditional building methods, and so the skills of the stonemasons was required once again. Today, St Andrews has a number of family operated stonemasonry companies in addition to a Monument Conservation Unit at the cathedral (operated by Historic Environment Scotland) to maintain both the cathedral and castle. In recognition of the high number of listed building in the region, Fife Council have also established a Heritage Scheme and as a result these traditional skills are once again very much part of the St Andrews working life.

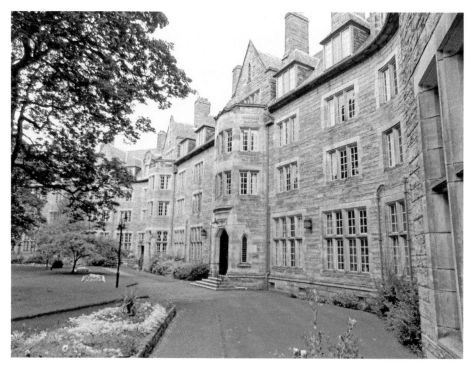

St Salvator's Hall, built in the 1930s with fine finishes.

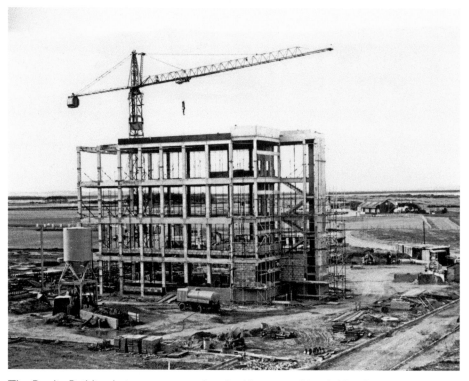

The Purdie Building being constructed at the University North Haugh.

# THE UNIVERSITY

During the Second World War, many of the Polish soldiers based in the St Andrews area took up studies at the university, as well as establishing art and wood carving clubs within the school's buildings. After the war the university continued to grow, leading to more student accommodation being required; in 1949 it purchased the Grand Hotel, a once prestigious building that overlooks the Old Course and the sea. Essential repairs were also carried out to several of the older buildings. Relationships between the campus based in Dundee and the one in St Andrews, however, started to become strained, which led to the suggestion that St Andrews should concentrate on degrees in those subjects deemed more 'academic' while Dundee would have a more 'technical' focus. In 1967, the University of Dundee was formed and started to operate separately from St Andrews.

In the run up to the ending of the partnership, the management at St Andrews University were aware that a number of teaching facilities established at the Dundee campus would be lost to them. So, in preparation, plans were been made to build new facilities just outside the existing town boundary, in an area known as the North Haugh. Possibly the most prominent buildings here are the School of Chemistry, housed in the Purdie Building, and the Andrew Melville Halls, their first purpose-built wardened student accommodation. Since then the university has continued to flourish and, with numerous buildings and around 7,000 students attending, the university is the largest single employer in St Andrews, providing work for in excess of 2,000 staff.

In 2013, the university commenced a project to become more energy efficient. They purchased the former Guardbridge Paper Mill (which closed in 2008) with an aim to turn it into an Energy Centre. Biomass systems were installed using locally sourced wood, with the hot water produced there being pumped via super-insulated underground pipes to provide heating to the university buildings in St Andrews. The development cost in the region of £25 million and is expected to save in the region of 10,000 tonnes of carbon emissions a year, and is part of the university's aim to become entirely carbon neutral. The development has also created a large number of highly skilled jobs, and the university estates department has extended their apprenticeship scheme to provide apprenticeships at the Guardbridge facilities.

The chemistry department staff *c.* 1970.

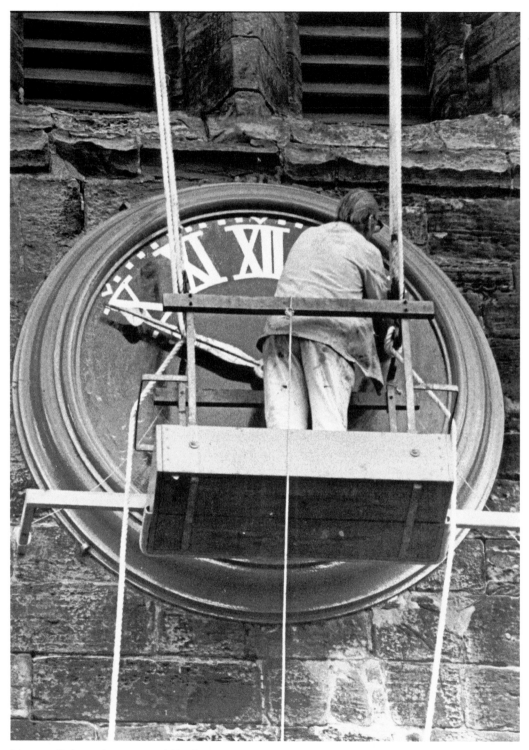

My grandfather, who was a gold leaf expert, painting the numbers on St Salvator's clock face in 1980.

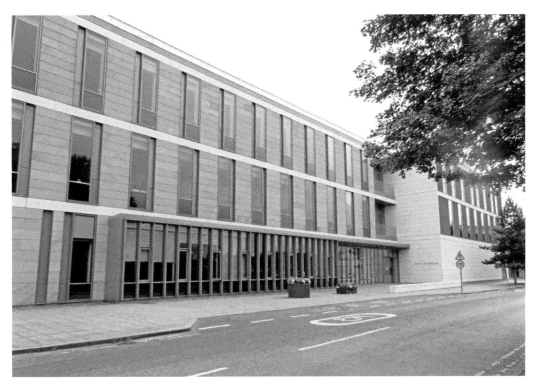

The School of Medicine at the North Haugh.

The original Purdie Building housing the school of chemistry at the North Haugh. The building is named after Thomas Purdie, the professor of chemistry at the university between 1884 and 1909.

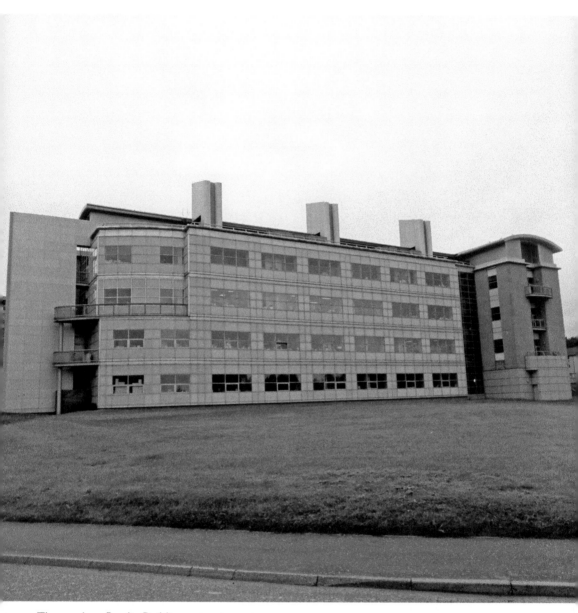

The modern Purdie Building extension.

Signage around the university stating their green intentions.

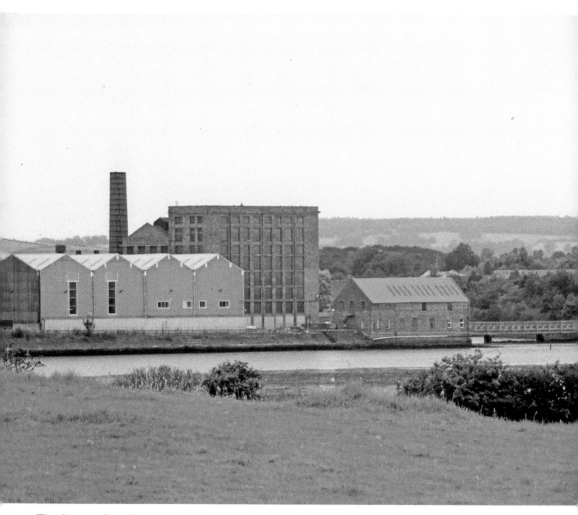

The former Guardbridge paper mill.

# FISHING

In the later part of the twentieth century, the fishing industry in St Andrews declined considerably. Larger boats were in use from commercial ports along the east coast and much improved transport links allowed fresh fish to be transported around the country. With the new boats becoming too large to berth in St Andrews harbour, the fleet soon dwindled. That is not to say that fishing does not remain a part of St Andrews. Crab and lobster fishing favours the smaller boats and piles of lobster creels now line the walls of the outer harbour.

Around twelve boats remain, fishing for all types of shellfish around the shores of Fife, with the catches being considered to be of high quality and much in demand, leading to them being sold both nationally and exported to the international market.

The inner harbour has experienced quite a revival as well. In 2015, plans were unveiled to add pontoons to the harbour with berths for up to thirty-two boats.

Phase one of the project was completed in 2016, and a number of pleasure craft are now berthed there.

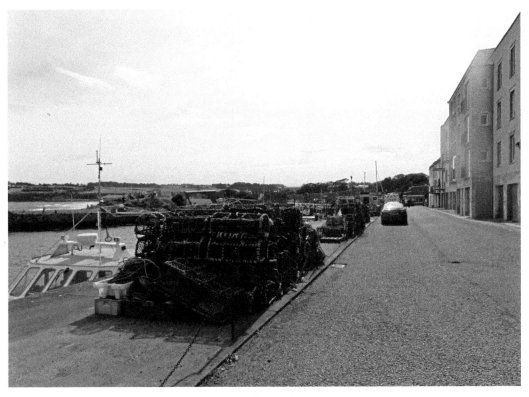

The crab and lobster creels lining the harbourside.

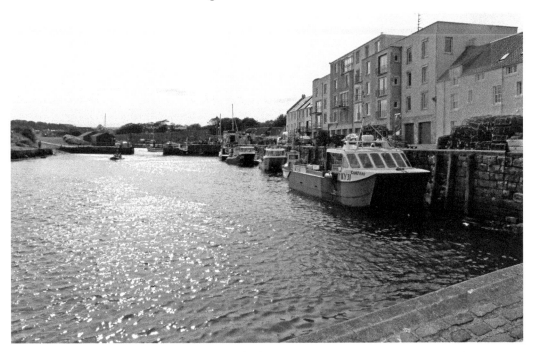

The fishing boats in St Andrews outer harbour.

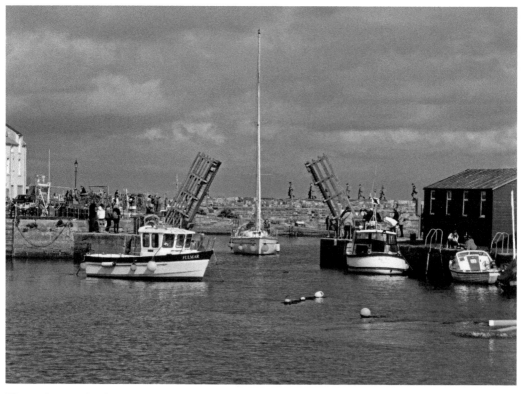

The pedestrian bridge across the harbour opens to allow larger pleasure craft into the inner harbour.

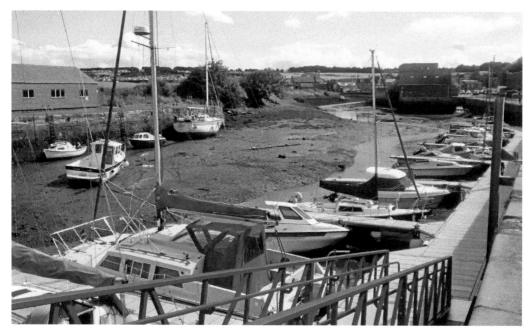

The pleasure craft at low tide, showing the restricted use of the harbour.

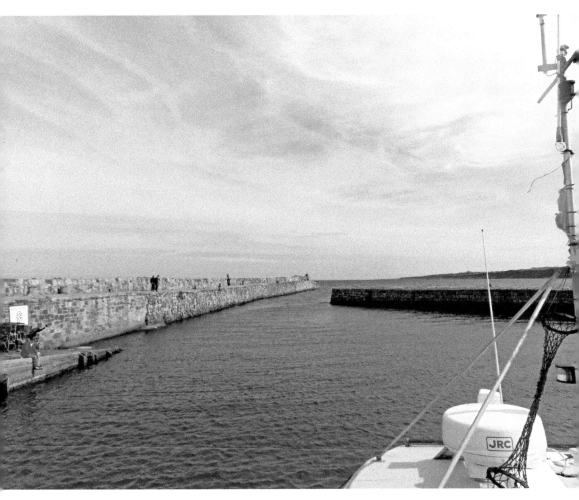

The extended pier.

# GOLF

In July 1946, the Open Championship once again returned to St Andrews. This was a significant competition as it was the first to be played since the start of the Second World War. Players from as far afield as Australia and America took part, and large crowds were attracted.

After the war, golf club manufacturing continued in St Andrews, but change was on its way. In 1945, the American company Spalding purchased Forgan's. Increased competition from overseas manufacturers – including other American companies – made the market for golf clubs increasingly competitive, and in March 1963 the St Andrews workshops were closed and the machinery sold.

With St Andrews becoming known worldwide and the 'Home of Golf', the numbers of visitors coming to play the game continued to grow and, as a result, more golf courses were created to accommodate the increased numbers – there are now thirteenth courses within the St Andrews postcode area. The Old Course, however, remains iconic and attracts thousands of players a year, including many of the rich and famous. It is estimated that around 45,000 rounds of golf are played on the Old Course every year.

The old Forgan's workshops also saw a new lease of life to cater for the tourist market. The building on the Links was opened as the St Andrews Woollen Mill, which ran successfully until 1988 when it was sold to the Royal and Ancient Club, who still have it today. The Market Street premises became a store for a local butcher shop and its heritage was forgotten until it was purchased and converted into a restaurant. During the ground works, several heads of golf clubs were found buried beneath the floor, bringing the buildings history back to life. As a result, the restaurant was named Forgan's. In 2008 the Forgan's brand was also reintroduced from St Andrews, offering clubs for sale online; Morris clubs are still manufactured under licence.

Establishments connected to golf remain large employers in the area, with the Fairmont complex employing up to 400 people and the Old Course Hotel employing up to 250.

The value of golf remains significant, not just for St Andrews but for Scotland as a whole, with news reports in 2013 estimating that it is worth more than £1 billion annually to the Scottish economy.

The Old Course.

The St Andrews Links Golf Academy.

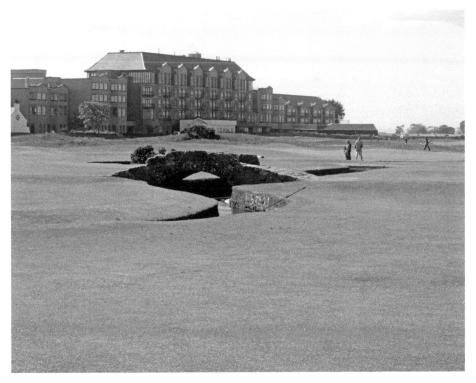

The Old Course Hotel.

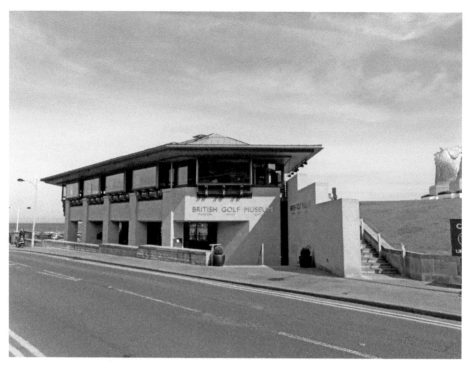

The Golf Museum.

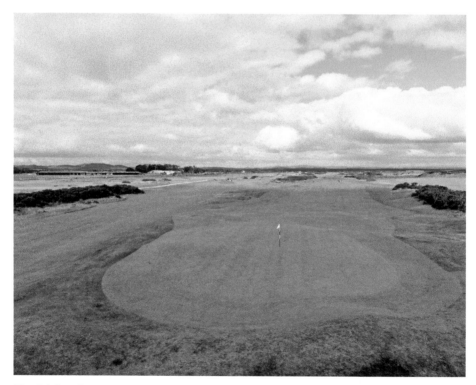

The Jubilee Course.

The Castle Course.

Auchterlonies Golf Shop.

The St Andrews
Golf Co.

The entrance for
Forgan's restaurant.

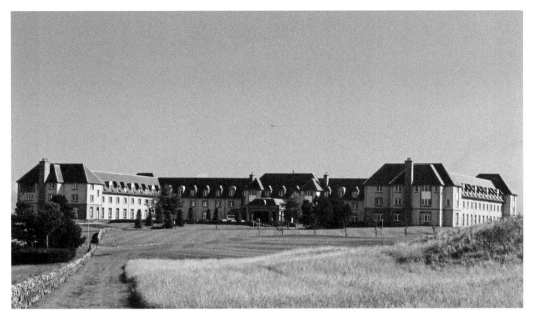

The Fairmont Hotel and Business Centre.

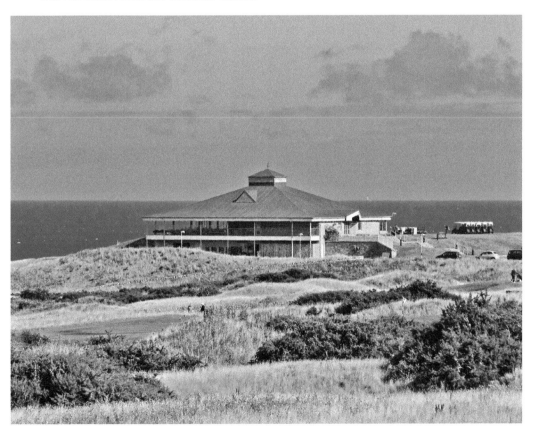

The Fairmont clubhouse.

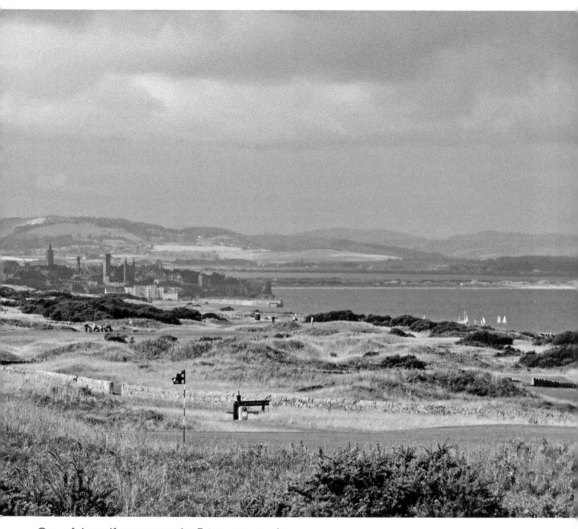

One of the golf courses at the Fairmont complex.

# TRAVEL AND TOURISM

The tourism industry remains one of the most important to St Andrews in terms of economy and employment. Since the twentieth century the tourist requirements have changed and many of the large hotels have been turned into housing, while smaller hotels (including 'pubs with rooms') have seen a resurgence in the town. One thing that has remained, however, is that the quality of all accommodation is high. Many of the tearooms that were once positioned around the town have been converted into pubs. While it would be reasonable to expect golf to be the top tourist attraction in the town, a report published in 2014 by St Andrews Partnership found this not to be the case. In a survey carried out in 2013, it found that 33 per cent of people's main reason to visit was the historic nature of the town and the scenery; 22 percent were visiting for shopping (St Andrews has in excess of 100 different shops, many operated by small, independent retailers rather than the big chains); 21 per cent were attracted by the

beaches; and just 19 per cent were visiting to either play or watch golf. The same report found that the beaches, cathedral and the harbour were the top three visitor attractions.

Despite the relatively small size of St Andrews, it is estimated that in excess of 600,000 people visit the town every year, and in the high season there can be as many as 10,000 visitors at any one time. That is, however, dwarfed when the golf Open Championship is on: it is estimated around an extra 200,000 people visit at this time. The largest annual crowd-puller is the Dunhill Golf Championship, which attracts in excess of 20,000 people, with over half staying in the town.

Another annual attraction that brings more people from the surrounding areas into the town is the annual Lammas Market, one of the oldest surviving medieval fairs in Europe. Originally established to celebrate the harvest, the Lammas Market would be a day that

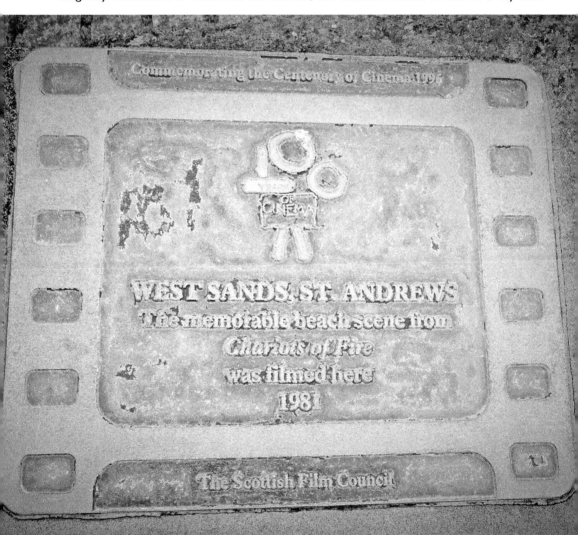

Plaque commemorating the filming of *Chariots of Fire* at the West Sands.

The 'witches' sands, known by this name due the close proximity of Witch Hill, where executions took place during the witch trials.

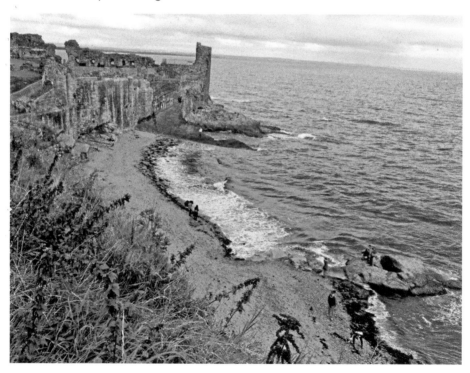

The Castle Sands.

The East Sands.

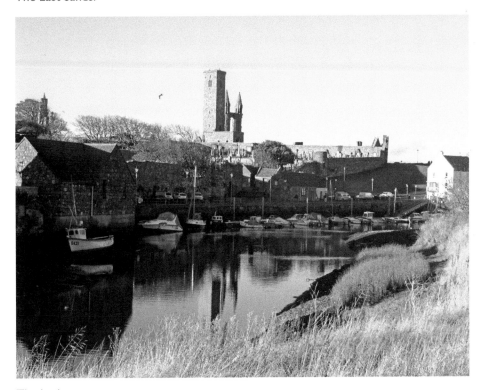

The harbour.

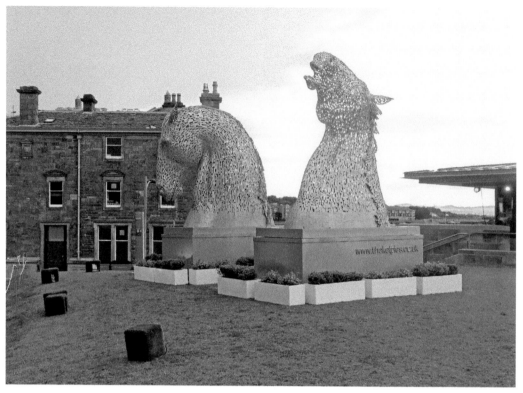

The Kelpies visit St Andrews.

The 'tourist train' transporting visitors around the attractions.

Marquees and stands being constructed for the Dunhill Championship.

included hiring and firing new house staff for the wealthy, the selling of everything from bread to livestock, and the day that the rent was collected. Today it is a more joyous time, with a European market, traditional market stalls and fairground rides.

With so many attractions, the value of tourism to the town is considerable. It has been estimated that visitors spend almost £100 million a year in the town, which plays a significant part in supporting the local economy and workforce.

The Lammas Market.

*Above*: St Andrews
Holiday Park
offers affordable
accommodation
for families visiting
St Andrews.

*Right*: Hamish
McHamish, known as
'the cat around town',
became a popular
attraction for both
locals and tourists due
to his antics around
the town shops. After
his death a statue was
put up in Logies Lane,
which still attracts
tourist attention today.

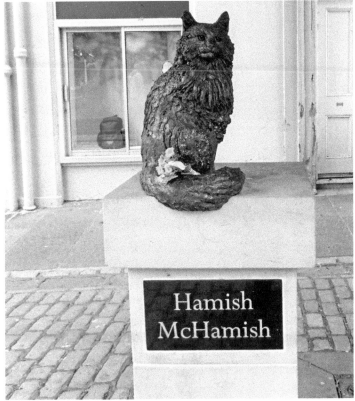

# BAKERS

Bakers have been an important part of the economy of St Andrews for some time. At the end of the sixteenth century it was estimated that the number of bakers – between sixty and seventy – matched the number of brewers in the town. There was so much demand that the university imposed a price structure for bread to prevent the students from being overcharged. Over the years, many of the bakers became tearooms, but the bakeries are once again increasing in popularity.

The oldest bakery in town is Fisher & Donaldson, which was established in 1919. Now a fifth generation baker, Fisher & Donaldson have a total of seven shops spread between St Andrews, Dundee and Cupar. McArthurs, another old baker brand, also still survives in St Andrews, operated by Fisher & Donaldson. With over 400 products on offer – all hand-made in their own bakehouse, along with handmade chocolates – the bakery attracts people from all over to sample their sweet delights. The tasty treats have even been sampled by royalty, with the bakery being awarded a royal warrant in 2011 by Her Majesty the Queen.

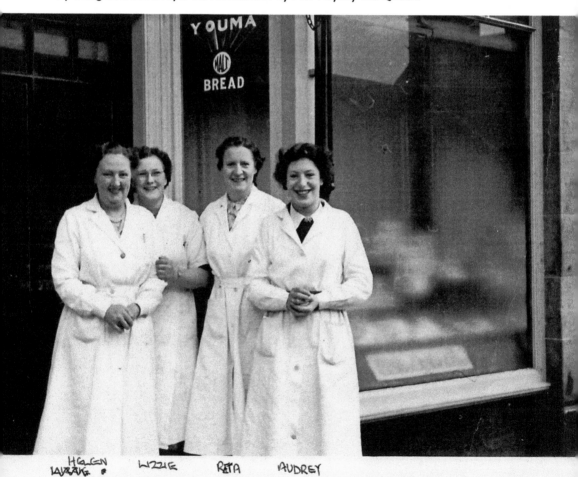

The staff of McArthurs bakery. (Date uncertain)

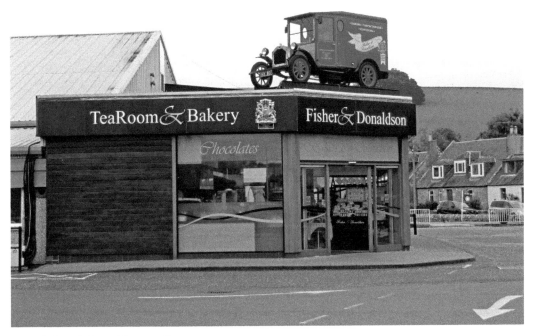

Fisher & Donaldson in Cupar.

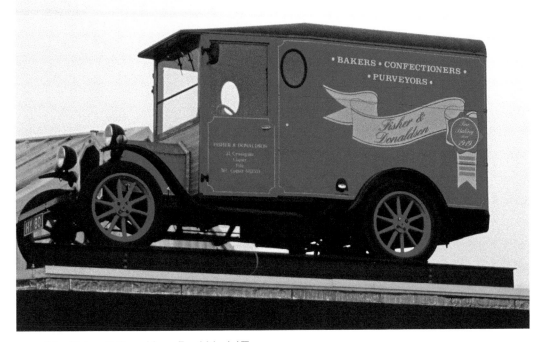

The Fisher & Donaldson Ford Model T van.

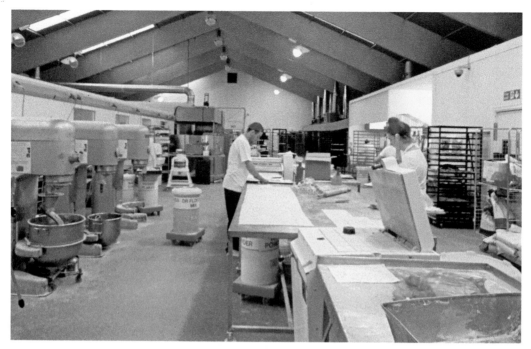

Inside the bakery at Fisher & Donaldson. (Kindly permitted by Fisher & Donaldson)

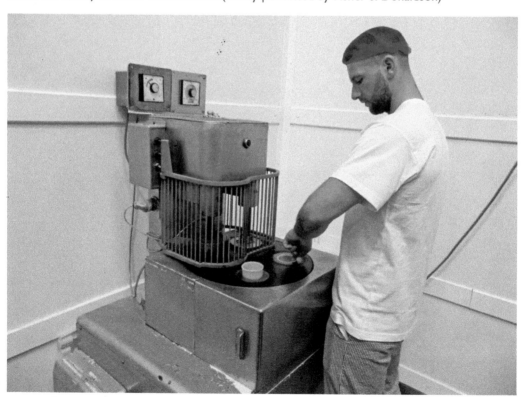

Pie shells being made by hand at Fisher & Donaldson. (Kindly permitted by Fisher & Donaldson)

Fisher & Donaldson's hot snacks vending machine in St Andrews.

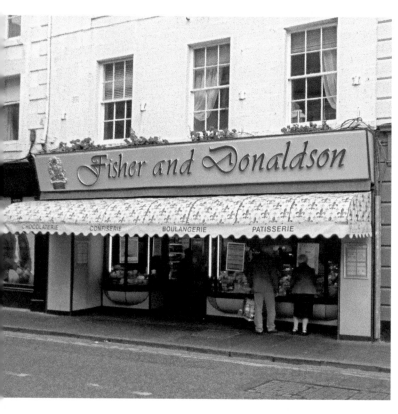

Fisher & Donladson's
St Andrews store.

Today, Fisher & Donaldson continue to go from strength to strength and provide employment for around 120 people across their shops and bakehouse.

# BREWERIES

The closure of the Argyle Brewery signified the end of brewing in St Andrews. Wilsons operated successfully from the premises for many years and, although they did bottle beer for brewers, none was actually brewed on the premises. In 1984, Wilson ceased trading and the old brewery has since been demolished to make way for housing, with only the original entrance remaining.

Recently, brewing has made a comeback into the town. In 2012, The St Andrews Brewing Co. was established in nearby Glenrothes, before moving to a premises on South Street that also operates as a pub and restaurant. Only brewing 750 bottles of beer at a time, the brewery is returning to the earl days of brewing in St Andrews, with each batch being hand-brewed, bottled and labelled.

The year 2012 was also when the former site of Haig's Brewery, which had been incorporated into the Guardbridge Papermill, once again started production. Reopening as the Eden Brewery, the company is to operate both a brewery and a distillery from a single site and offer a wide range of gin, whisky and beer.

The company has grown considerably since its inception, with an annual turnover of around £3 million and providing employment for over twenty people. The brewing industry looks like it is back to stay in St Andrews.

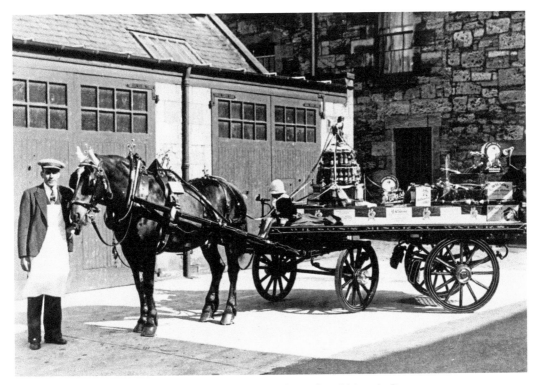

Wilson's aerated water manufacturer trading from the old Argyle Brewery.

The entrance to the former Argyle Brewery.

Housing on the former brewery site.

St Andrews Brewing Co., South Street.

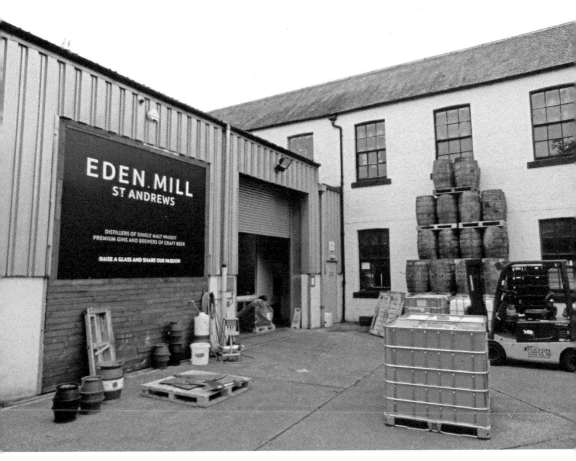

Eden Brewery.

# ABOUT THE AUTHOR

St Andrews is my hometown. It is where I was born and raised and where most of my family still live. I first became interested in the history of the town as a child when my grandfather, who was a painter, artist and gold leaf expert, used to tell me tales of the buildings he was working in. My initial interest was in the paranormal side (just like any wee boy), but being told a place was haunted was never enough for me, I wanted to know who haunted it, why and what had happened. A natural progression was to delve deeper into the history of the town, its people and its industries, and as result I have written a number of local history books exploring different aspects of the town.

I do hope you have enjoyed the book and I welcome any feedback or additional information anyone may have. You can contact me through my website at www.gstewartauthor.com or find me on Facebook at Gregor Stewart, Author and Paranormal Researcher.